PHOTOGRAPHING HISTORY
The Career of Mathew Brady

ABOUT THE BOOK

Nearly everyone who aspired to be someone important in mid-nineteenth-century America wanted to pose before the camera of Mathew Brady. In this memorable biography Dorothy and Thomas Hoobler tell the moving story of Brady's rise from obscurity to fame, his gambling everything and losing nearly all in a determination to record the Civil War in photographs, his death in lonely poverty with spirit still undefeated. Mr. and Mrs. Hoobler illumine their absorbing account with some fifty Brady photographs which are his legacy to us from times of historic significance.

At the height of Brady's fame, when the rich and ambitious made pilgrimages to his New York studio, they were awed by the likenesses lining the walls. It seemed that the entire nineteenth century was there: from Dolley Madison and Presidents Andrew Jackson and John Quincy Adams to the showman P. T. Barnum, the actress Charlotte Cushman, and Edward, Prince of Wales.

The authors evoke vividly Brady's dream that the priceless collection of photographs he had gathered would become the nation's treasured memory as well. But the nation avoided recalling the painful Civil War days that Brady had preserved. History has a sloppy memory. Brady's memory was too painfully sharp. Now in these pages his life and vision are restored dramatically.

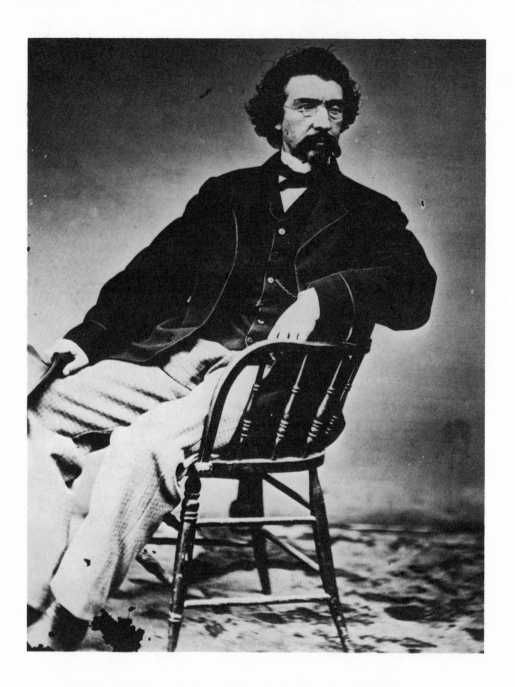

Mathew Brady as he looked shortly before the Civil War.

PHOTOGRAPHING HISTORY

THE

CAREER

OF

MATHEW BRADY

By Dorothy and Thomas Hoobler

G. P. PUTNAM'S SONS
NEW YORK

Library of Congress Cataloging in Publication Data
Hoobler, Dorothy. Photographing history. Includes index. Summary:
A biography of the photographer of famous men and women of his time
who left his studio at the zenith of his career to travel with Union troops
photographing the Civil War. 1. Brady, Mathew B., 1823 (ca.)-
1896—Juvenile literature. 2. Photographers—United States—
Biography—Juvenile literature. [1. Brady, Mathew B., 1823 (ca.)-
1896. 2. Photographers] I. Hoobler, Thomas, joint author. II. Title
TR140.B7H59 1977 770′.92′4 [B] [92] 77-3009
ISBN 0-399-20602-7

TABLE OF CONTENTS

PHOTOGRAPHING HISTORY

The Career of Mathew Brady

THE MAKING OF THE PRESIDENT, 1860

ON February 27, 1860, a strange-looking figure appeared at the photographic studios of Mathew Brady in New York City. The man who came to have his picture taken was a giant of a man, "half alligator, half horse," according to one of the men who met him that day. His plain black suit was of cheap broadcloth and terribly wrinkled from being packed in a suitcase on a long trip. An ordinary black ribbon, carelessly wound about his neck, served as a tie. Yet this was Abraham Lincoln of Illinois, whose reputation as a compelling speaker had brought him an invitation to speak before the New York Young Republican Club.

Mathew Brady himself was at the door of the gallery to welcome Lincoln and the New York Republicans who accompanied him. Brady clasped Lincoln's hand warmly and showed him to the gallery of portraits that he had taken.

The walls were lined with pictures of America's famous men and women—Andrew Jackson and Dolley Madison; the writers Edgar Allan Poe and Washington Irving; Samuel F.B. Morse, the famous inventor; Horace Greeley, the journalist; and show business figures

such as P. T. Barnum and Charlotte Cushman. The large portraits of Webster, Clay, and Calhoun occupied a place of honor. The faces of the Presidents were here. Brady had taken the picture of almost every President since John Quincy Adams. The only missing one was William Henry Harrison, who had died after a month in office.

Lincoln's face wasn't as famous as those that graced Brady's wall, but there might be a place for him there yet. People said he was a comer in the new Republican party. He had debated Stephen Douglas on the issue of slavery and gained a name for himself in Illinois. Brady had taken Douglas's picture several times. He didn't want to miss anyone who might become a great American. He took pictures of almost everyone in politics as well as of show business people, writers, painters, inventors—everyone America called great.

Most of them were happy to sit for the camera at Brady's. Having Brady take your picture was a mark of success and status. Many lesser-known people came to his studios to pay for the privilege of a portrait by Brady. His popularity was so great that he had opened a second studio in New York and another in Washington.

The tall, gawky Lincoln was a little ill-at-ease in the plush surroundings of Brady's gallery. He was probably thinking about the speech he was going to make that night. It was important that he do well. Brady showed him into the camera studio, the bright room where many skylights let in the daylight.

Brady's appearance contrasted with Lincoln's. Brady was a slightly built, energetic man with a long mustache and goatee. His curly dark hair was perpetually unkempt. As Lincoln watched, he bustled around the room adjusting the shades that controlled the lighting, telling a few jokes. Brady's studio helpers smiled at each other. They had heard the jokes a thousand times before. Brady used them to relax all his customers.

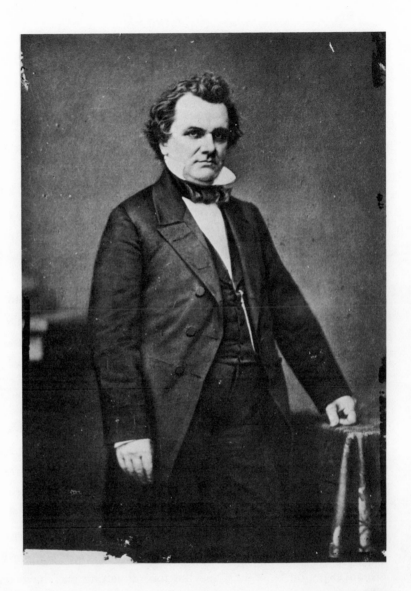

Stephen Douglas was another of the Presidential hopefuls in the election of 1860. Brady's studio took this photo for distribution around the country in the campaign.

Lincoln was such an imposing figure when standing straight up that Brady posed him that way instead of seated. He moved Lincoln over to a scenery backdrop with a pillar, perhaps because it suggested the Roman Senate. Lincoln had lost when he had opposed Douglas for the United States Senate seat from Illinois, but he was young. He might run again. And, there! Let his hand rest on a stack of books. That would give a little touch of a man of learning. Lincoln hadn't gone to school, people said. Well, that was no disgrace either. Brady himself had no formal education.

Brady's assistants adjusted the reflectors that kept shadows from appearing on the sitter's face. Then they brought up the head and body clamps. Taking a picture in those days wasn't done in an instant, as it is today. Even with good light, the subject had to stand perfectly still for many seconds. To make sure Lincoln's head wouldn't move, they would tighten an iron clamp around the back where it wouldn't show. A second clamp would hold his back.

But here was a problem Brady hadn't encountered before. Lincoln was so tall that the adjustable stand on which the head clamp rested wouldn't reach high enough. They all smiled at this. Lincoln was used to jokes about his height; he may have told one himself while an assistant looked for a stool to set the head clamp on. The camera was moved forward a bit. The photograph would have to show Lincoln from the knees upward to keep the stool out of the picture.

Perhaps it was the delay, or perhaps the false backdrop, but Lincoln grew stiff and nervous as the camera was readied. He wasn't a man to put on false airs, and the formal setting may have seemed out of place to him. Brady later recalled, "I had great trouble making a natural picture."

Brady's camera operator lifted the black cloth on the back of the camera and ducked under it. He peered at the upside-down image

of Lincoln that the lens projected onto the ground glass there. Brady's eyes were not as good as they once were, and he probably wouldn't have done the actual photographing himself. He had a number of talented operators who did the day-to-day work of the busy gallery.

The operator wasn't quite pleased. Lincoln had a long neck with a prominent Adam's apple. He looked bony on the ground glass. Brady suggested Lincoln adjust his collar a little. Lincoln knew what Brady meant. "Ah, I see you want to shorten my neck," Lincoln said with a smile. The photographer and the politician looked at each other. "That's just it," Brady said, and they both laughed.

Another of Brady's assistants brought a freshly prepared photographic plate from the darkroom, where it had just been coated. It had to be fresh and sticky to work properly. The assistant placed it in the camera, and its protective shield was removed.

Brady looked at Lincoln again. He was relaxed now, and Brady nodded at the operator, who removed the lens cap to take the picture. Seconds passed. The operator's experience with the camera told him how long to expose the plate, depending on the brightness of the light coming through the skylights. Finally he replaced the lens cap, and Lincoln expelled a long breath, looking around hopefully for someone to loosen the head clamp. Like photographers in all ages, however, Brady wasn't satisfied with just one shot. A second plate was brought from the darkroom, and a third, while Lincoln stood patiently, the clamps in place. The Republican organizers who accompanied Lincoln began to look at their watches. There were important people to meet.

Finally Brady was finished. Lincoln was released from the clamps, and he and Brady shook hands again, looking at each other with new friendliness at their shared joke. Brady watched his callers go off

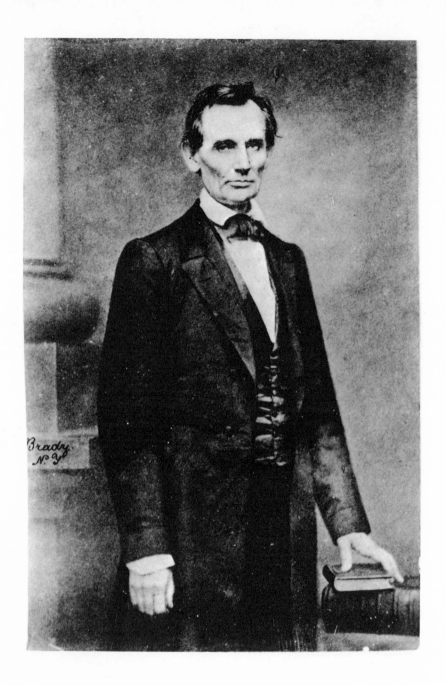

The "Cooper Union" portrait of Lincoln.

into the bustling city. He turned and went back upstairs to the laboratory.

Brady's assistants were already developing the plates of Lincoln. In the dim yellow light of the laboratory Brady peered into the tray of chemicals to watch the image come forth. After seeing thousands of pictures develop, he confessed that the sight never failed to thrill him. What he saw was a negative image, but his practiced eye could visualize the picture of Lincoln as it would appear printed on a white card. Here was the man captured on paper as he had looked in those few seconds in Brady's studio, preserved for all generations to see. He would never appear quite the same again.

What would become of Lincoln? Brady might have reflected. An interesting man, but perhaps too human, too unsure, too aware of his own faults to be successful in politics.

What Brady couldn't have seen was how hard Lincoln worked. Lincoln knew the New York speech, to be given at the great Cooper Union Hall, was a big opportunity for him. When he had received the invitation the October before, he knew what the topic of his speech would be. The Republican party was against allowing slavery in the new territories of the Union. Many people said that if a Republican was elected President in 1860, it would lead to war with the slave-holding states of the South. Lincoln decided to write a speech setting forth boldly the arguments against slavery.

Brady wasn't at Cooper Union that night. There was no way a photographer of the time could take a picture in the dimly lighted hall. He missed what was to be a famous speech. Lincoln started awkwardly. He was nervous again. His Kentucky accent sounded uneducated to the New York audience. But as he went along, he gained strength and confidence in the words he had painstakingly prepared. His audience began to sit up as the fiery, plain-speaking Lincoln

drummed out his points. At the end they were standing and cheering.

In the morning the newspapers were full of the news of Lincoln's speech. Brady must have read them with some surprise. Four newspapers printed the entire speech. A reporter wrote, "No man ever before made such an impression on his first appeal to a New York audience."

Brady might have looked at the photograph of Lincoln a second time. Here was a face that could find a place on Brady's wall sooner than he thought.

Meanwhile, the invitations rolled in to have Lincoln speak again. He spoke at Hartford, New Haven, Providence, and other cities throughout New England. In the West the people already knew Lincoln; now they were getting to know him in the East. And people began saying: this Lincoln might make a good President.

Not everyone could squeeze into the packed halls to hear Lincoln speak. He could not come to every town. Many people depended on what they read in newspapers for an idea of what Lincoln was like. Newspapers and magazines wanted to print Lincoln's picture, and they knew where they could find it: Brady's. Brady could be depended on to have pictures of anybody who made news.

Brady also made small pictures, called *cartes de visite*, of the famous. People collected these in albums. Letters and orders for Lincoln's picture came into Brady's studios. His lab men were kept busy turning out *cartes de visite*, sending them out to those who wanted to see what this strange man looked like. And when they saw Brady's photograph of Lincoln, many of them thought he looked like a man the country needed. They saw strength there and honesty and character to lead the country.

The following year Brady had Lincoln in front of his camera again. Only this time the scene was Brady's Washington gallery, and

Lincoln arrived as the President-elect. The city marshal of Washington accompanied Lincoln, and when they arrived, the marshal started to introduce Brady to the President. Lincoln smiled and extended his hand. "We know each other," he said. "Brady and the Cooper Union speech made me President."

CAPTURING LIGHT

WHEN he met Lincoln, Brady was only in his thirties, yet he was already one of the best-known photographers in America. Like Lincoln, he came from the backwoods of the country. Little is known of his parents, Julia and Andrew Brady. His father came from Ireland to find work in America. Brady was even unsure of the year of his own birth, placing it around 1823 or 1824, in Warren County, New York, near Lake George.

In the census of 1830 we find the Brady family composed of four sons and two daughters, all under ten years of age. Their mother was between thirty and forty, and their father in his forties. Mathew was around seven years old. The Brady family was living in Johnsburg, New York. Johnsburg was a township in Warren County, mountainous and rocky, where the chief industry at the time was cutting hemlock trees for the nearby tannery.

We don't know what kind of work Andrew Brady did, but Irish, English, and Welsh immigrants had settled in Warren County since about 1790 when John Thurman founded the town. Prosperity had come quickly to the area at first. Thurman was an ambitious busi-

nessman. He brought workers from Westchester County, near New York City, to operate his businesses and populate the area. Thurman built the first calico printing mill in the United States in Johnsburg in 1797. But Thurman was killed by a bull in 1809, and after his death the area began to decline. The calico mill had closed by 1830, leaving only logging as a local industry. Besides loggers and a shop-keeper or two, the only other residents were a few farmers trying to scratch a living from the rocky land in the foothills of the Adiron-dacks. Not a promising environment for a boy who would grow up to cater to the cream of New York and Washington society. What education Mathew Brady had, he must have gotten on his own. Even after he became a successful businessman, he wrote few letters per-sonally.

We know that Mathew had ambitions, for he left home early to seek his fortune on more promising soil. Something attracted him to art. To the south of Lake George lay the town of Saratoga, already a fashionable resort famous for its springs. It was at Saratoga, when Brady was in his early teens, that he met William Page the painter.

Page was a young artist struggling to find work. The wealthy clientele at Saratoga were often good customers for portrait paint-ers. Page may have needed an assistant, and Brady recalled that Page gave him copying work to do. Later Brady accompanied Page to Albany, the capital city of New York.

Sometime in the late 1830s Page decided to return to New York City, and Brady went along. Page was a friend and former pupil of Samuel F. B. Morse, who taught art at New York University. Morse's small salary wasn't enough to provide him with funds for the devel-opment of his invention, the telegraph. He raised extra money by doing sketches and portraits on the side.

Morse was an American genius whose interests were wide-ranging.

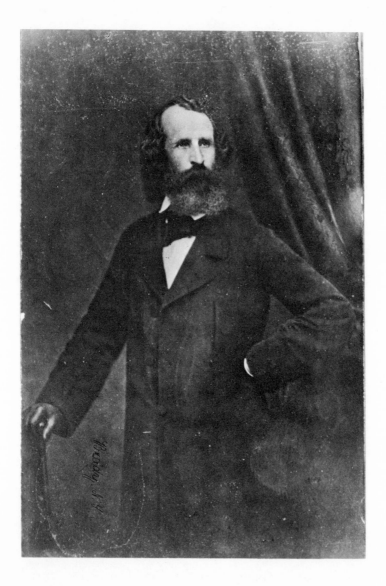

Brady's photograph of William Page, the painter to whom he was apprenticed. Page later left America for Europe, trying to find the artistic greatness that he never quite attained.

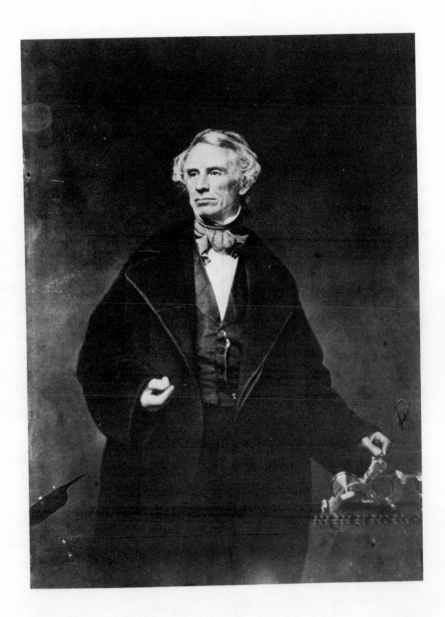

Samuel F. B. Morse was both artist and scientist. The instrument in Morse's hand is an early telegraph model.

In the winter of 1838–39 he was in Paris, trying to find investors and support for his telegraph. The telegraph would one day bring Morse fame and fortune and would revolutionize world communication, but at the time Paris was agog with news of another invention —the daguerreotype.

Morse wrote his brother from Paris that he had met the inventor Daguerre and seen examples of his daguerreotypes, the little mirror-like pictures that were remarkable reproductions of nature. "No painting or engraving ever approached them for the fineness of their detail," he wrote.

One Frenchman exclaimed on seeing a daguerreotype, "From this day painting is dead!" Daguerreotypes were among the first examples of what we call photography. To an age that had never seen a photograph, much less movies or television, daguerreotypes were something miraculous. Crowds of people lined up to see the examples of the new "art" whenever they were displayed.

The beginnings of photography went back centuries before Daguerre. In the Renaissance a popular diversion was the *camera obscura*. *Camera* was the Italian word for room; a *camera obscura* was a darkened room with a small hole in one wall. Objects or scenes placed in front of the hole outside the room would be projected against the opposite wall inside the room.

Artists developed smaller models of the camera obscura, using mirrors and a lens to reflect the image onto a glass screen on top of a small box, still called a camera. A sheet of paper could be placed over the glass and the image traced to aid artists in making a "perfect" reproduction of natural scenes.

Inventors and artists had been striving for a long time to find a way to transfer the camera's image directly to paper. Earlier in the nineteenth century Josiah Wedgwood, an Englishman, succeeded in

making a few fragile photographs on white paper coated with silver nitrate, but he had to keep them in total darkness. He could look at them only a few times by the light of a dim candle before they turned black. The problem was in keeping a picture fixed, that is, in stopping it from turning completely dark or fading away when it was looked at in daylight.

Then a Frenchman, Joseph Nicephore Niepce, found a way of using light to etch a scene onto the surface of a chemically treated piece of metal. This was a permanent picture. The scene that Niepce made from the window of his home in 1826 is today regarded as the first permanent photograph.

By no means was Niepce's process perfect. The metal plates on which he made his "heliographs" were shiny and somewhat crude in detail. In addition the exposure time needed to make a picture was around eight hours.

Then Niepce received a letter from Louis Daguerre, co-owner of a Paris theater called the Diorama. By using lighting and huge transparent paintings, Daguerre created theatrical illusions of wide-open spaces and the passage of time. His Diorama was a very primitive form of motion picture. Daguerre also had been trying to fix the images of the camera obscura. When he heard of Niepce's work, he offered to share his ideas. He thought Niepce's discovery might be useful in the Diorama.

Niepce was at first suspicious of Daguerre, but he became convinced that Daguerre had original ideas that could help in the work. "A camera as perfect as Monsieur Daguerre's is needed," he wrote. In 1829 the two men formed a partnership to develop "heliography." In 1833 Niepce died, but Daguerre carried on the experiments, assisted by Isidore Niepce, Joseph's son. By 1837 Daguerre was successful in making the pictures that he called daguerreotypes. Because

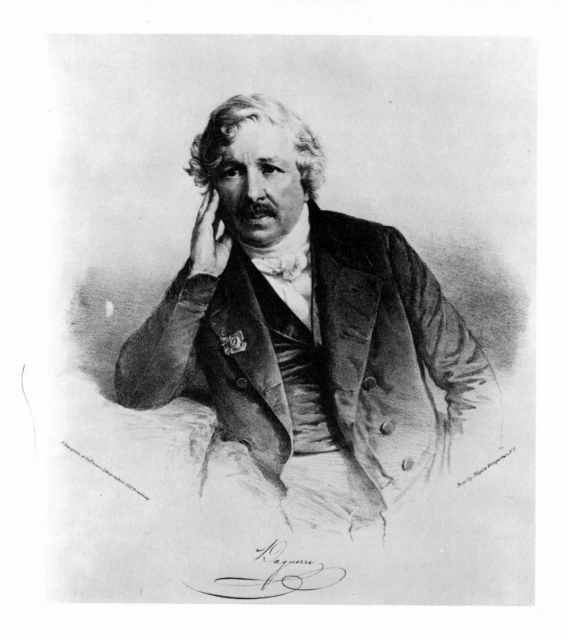

Louis Daguerre was reluctant to sit before the camera for his own portrait, and this is an engraved print from one of the few daguerreotypes of him.

they were of shiny metal, they were harder to look at than modern paper photographs, but their sharpness of detail was virtually perfect. Morse wrote that with the aid of a powerful magnifying glass a viewer could make out tiny details in the background of daguerreotyped scenes.

The French Academy of Sciences offered Daguerre six thousand francs a year for life, and Niepce's son four thousand francs yearly, if they would reveal the details of the daguerreotype process. They agreed.

On August 17, 1839, the method of making daguerreotypes was scheduled to be revealed by Daguerre before the Chamber of Deputies of the French government. The hall was thronged with spectators; outside, those who could not squeeze in waited eagerly for news of the proceedings. Daguerre himself was unable to speak, but a representative told how daguerreotypes could be made.

Almost immediately chemists and opticians were besieged with orders for the equipment and materials necessary to produce a daguerreotype. All Paris was caught up in the excitement. Within days copies of the daguerreotype instruction booklet reached the other cities of Europe.

By September 20, 1839, copies of Daguerre's manual were in the United States. On September 28 Morse exhibited a daguerreotype of the Unitarian Church that he had taken from the third floor of New York University with an exposure time of fifteen minutes. According to Morse, a Mr. D. W. Seager had made a daguerreotype in New York a few days earlier. The age of photography had begun.

PHOTOGRAPHY IN AMERICA

MATHEW BRADY and William Page arrived in New York just about the time the first daguerrean manuals were being distributed in the city. Page and Brady went to see Morse, Page's old teacher and friend, where they learned of the exciting art. Morse was already offering to teach others the practice of daguerreotyping for fifty dollars.

New York was growing rapidly when Brady first arrived there. The population of the city nearly quadrupled between 1825 and 1835. Irish immigrants swelled the population, providing cheap labor and a target for politicians. Anti-Catholic and anti-Irish prejudices ran high. Brady was at least one generation removed from Irish soil. He sought a higher place than the new immigrants who were taking jobs as servants for six dollars a month. None of that for Brady—he aspired to be an artist!

Still, even artists had to eat, and Brady worked for a while as a clerk at A. T. Stewart's department store at the corner of Broadway and Chambers Street. The handsome store was in the heart of the New York business district. As Brady walked to work he could

Brady's portrait of A. T. Stewart. Years before this picture was taken, Brady worked as a clerk in Stewart's department store.

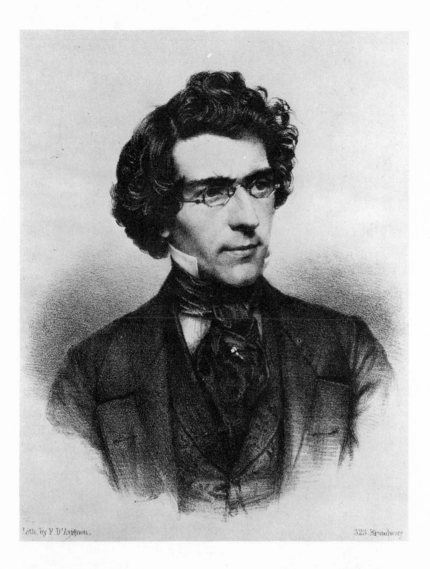

Lith. by F. D'Avignon. 323 Broadway.

A lithograph of Brady as he looked around 1851. Francis d'Avignon
made this lithograph as a copy of a daguerreotype taken by Brady's
studio. He also did the large lithographs for Brady's book, *The
Gallery of Illustrious Americans.*

see new stores opening and flourishing. The most fashionable and expensive stores were along Broadway, the main thoroughfare of the growing city.

Brady was spending part of his time learning about daguerreo-typing. He found making a good daguerreotype was not easy. Even Morse could not be certain of making a satisfactory picture every time. One problem was the long exposure time required. Morse and a fellow professor, John Draper, set up a glass house on the roof of New York University on Broadway. They managed to take some portraits—which Daguerre had thought impossible—in the bright sunlight on the roof, but even so, the exposure times were between ten and twenty minutes. At first the subjects had to keep their eyes closed because of the strong light. Another experimenter tried his luck at self-portraits by removing the lens cap and then running in front of the camera.

Other daguerreotypists speeded up the exposure time by using mirrors to bounce the direct rays of the sun onto the face of the person being daguerreotyped. The results showed a very pale and pasty-looking face. To soften the effects, the light was filtered through colored glass.

As satisfactory portraits became possible, commercial galleries for portrait–taking began to open. John Johnson and Alexander S. Wolcott opened the first "daguerrean gallery" in New York early in 1840. Robert Cornelius opened a similar establishment in Philadelphia at around the same time. In 1841 Albert Sands Southworth opened a gallery in Boston.

Brady was picking up all the information he could on the daguerreotype process. He may have taken Morse's course in daguerreotyping, but he later recalled being helped by Professor Draper and a Professor Doremus, both teachers of chemistry. There were public

lectures—for a fee—and exhibits of daguerreotypes that an intelligent, ambitious young man like Brady could have attended.

From a letter Brady wrote at the time we know he took up the business of making the miniature cases in which daguerreotypes were sealed under protective glass. At this early stage in his career we can see the mark of the businessman who deals in quality work. Brady wrote to Albert Southworth of Boston: "I have got up a new style case with embossed top and extra fine diaframe. This style of case has been admired by all the principal artists in this city. If you feel desirous to see my style of cases, if you will favor me with an answer I will send them by Horse Express."

In 1844 Brady opened his own daguerrean gallery at 205 Broadway near Fulton Street, across from the P. T. Barnum Museum. As Brady opened the doors to his third-floor walk-up studio and waited for his first customer, he must have been very proud. Modest though the gallery was, it had an address on Broadway, the greatest street in New York.

Later in his career Brady's poor eyesight and the pressures of business would keep him from taking photographs. At the beginning, though, he mastered the difficult art. When that first customer did arrive, Brady's work involved much more than seating the customer in front of the camera and taking the picture.

First a plate had to be prepared. Brady likely had a sturdy wooden box filled with the silver-coated plates that he had polished to an extremely high gloss. One of these shiny plates was put in another box where it was exposed to iodine vapors. After several minutes these vapors turned the plate a golden yellow, the signal that it was ready to be used. If left too long in the fumes, the plate would turn purple and not be as sensitive to light. The correct time in the iodine-vapor box could vary between five and thirty minutes. An experienced operator was needed to determine the exact length of time.

The golden-yellow plate was ready to be placed in the camera. Brady's camera, like all his equipment, had been specially made for him. Amateurs were sometimes successful in making their own cameras. But a precisely constructed instrument with lens supplied by an optician cost around fifty dollars.

Now the actual daguerreotype could be taken. Brady checked the image of the sitter on the ground glass, adjusting the lens to sharpen it. Now the protective slide was removed from the sensitized plate as it was inserted in front of the glass viewing screen. No shutter was needed for the lens; the lens cap was taken off to begin the exposure and replaced to end it.

Again, the proper exposure time was determined by trial and error, and the photographer's experience. (In Paris, Daguerre wrote, the exposure time varied between three and thirty minutes, depending on weather, season of the year, and time of day.) If a plate was exposed for too long or too short a time, the only thing to do was start over from the beginning. Little wonder that Isidore Niepce said it often took him an entire day just to make one picture, even after the process was perfected.

After the exposure was made, the plate still appeared blank and golden-yellow. Brady removed it and took it to a dark room where only dim candlelight was allowed. He heated several ounces of mercury to between sixty and seventy-five degrees centigrade. The fumes given off by the mercury were captured in a box that contained the exposed plate. Sometimes the camera itself was used for heating the mercury and developing the plate.

After several minutes the image appeared on the plate—if all the previous steps had been accomplished correctly. The thin film of mercury fumes on the surface of the plate gave it the light and dark tones that made the picture.

Now came the fixing, in which a salt solution was used to wash the

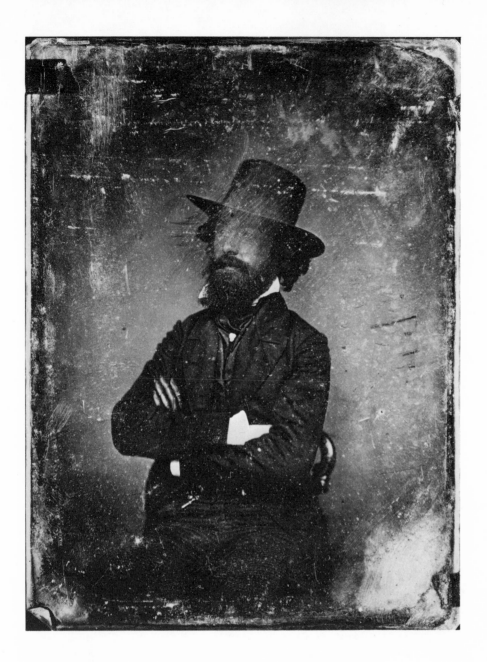

A jaunty portrait of Brady, now sporting a beard. The scratches are
the result of an attempt to polish the daguerreotype.

plate thoroughly, removing the excess silver and iodine so that the plate would not continue to darken when exposed to light.

The surface of the plate had to be protected by mounting it in a wood or leather case with a glass covering. When Brady gave the cased daguerreotype to his customers, he warned them not to take the plate out to clean it. Even a soft cloth rubbed across the surface would wipe away the mercury image.

Brady's price for a daguerreotype was between two and five dollars a portrait, depending on the size. His charges were moderately high. Price was never Brady's attraction. To stand above the competition—which he soon did—he had to have some other appeal. His success would result from his insistence on the highest quality work and his growing interest in recording history with his camera.

ILLUSTRIOUS AMERICANS

BRADY'S new establishment had plenty of competition. Skilled and unskilled daguerreotypists alike were going into business making portraits.

John Plumbe, Jr., established galleries in several cities. In New York Martin M. Lawrence and Jeremiah Gurney were two of the most famous of Brady's competitors. At least two magazines began publishing to report new developments in the field. The editor of *Humphrey's Daguerrean Journal* reported that in 1850 there were seventy-seven daguerrean rooms in New York alone.

The very best daguerreotypists thought of themselves as artists. The National Academy of Design, an association of young American artists of which Morse was president, elected Daguerre an honorary member. This was in 1839, making the United States the first country in which daguerreotyping was recognized as a form of art.

Appropriately so, for American art had always had the unmistakable stamp of the practical. In contrast to the long tradition and greater sophistication of European art, early American art works were commissioned portraits, serving to preserve a generation's faces

for the benefit of their descendants. Landscape artists in America tended to be overly sentimental, recording the scenes of the new world with the intent of glorifying them.

The new daguerrean art was based on scientific technology at which Americans felt they could excel. Indeed, Americans soon made technical innovations which improved the process of daguerreotyping. American artists found better ways to make daguerrean plates, coating them with silver by an electrotyping process to give a better surface. Mechanical plate polishers were another innovation. The boxes used to saturate the plate with iodine fumes and to fix the image were redesigned by Americans. New combinations of chemicals to improve or speed up the process were tried. By the 1850s the exposure time had been reduced to an average of fifteen seconds.

An innovation credited to Brady was the use of the skylight. Maybe it was only the result of finding out that the top-floor walk-up had cheaper rent, but the skylights at Brady's, combined with floor-model reflectors within the studio and filters over the lens, made a pleasing, dramatic portrait. Many of these techniques for filters and studio reflectors are still used by modern photographers.

Success came quickly to the young man barely into his twenties. Satisfied customers told others of the quality of the daguerreotypes that came from Brady's. Professional recognition came quickly too. In 1844 the American Institute of New York held the first competitive photographic exhibit in the United States. Brady realized the importance of the competition and spent much time carefully preparing the best examples of his daguerreotype work for it. He was rewarded with the silver medal—the highest award. From 1844 to 1849 Brady entered the exhibit and each time took the highest award.

In terms of reputation his rewards were far greater. It became fashionable for the wealthy to have their portraits done by the best

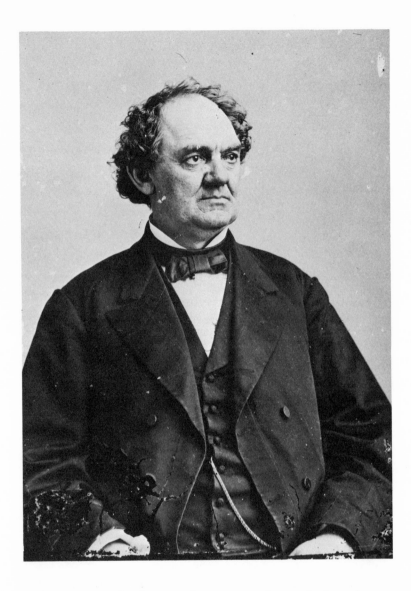

P. T. Barnum, the famous showman, as he sat before the camera in
Brady's studio. Barnum's Museum was across the street from Brady's
Fulton Street gallery.

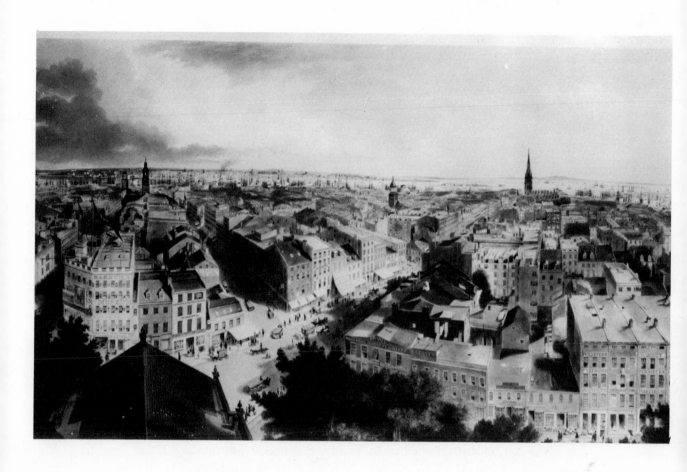

An engraving of downtown New York in the late 1840's. The corner of Fulton Street and Broadway is shown, with Brady's gallery in the center foreground, just beyond the trees. The white building at far left, facing on Broadway, is Barnum's Museum.

daguerreotypist in New York. Readers of the daily press as well as the daguerrean journals were familiar with the name: Brady of Broadway.

Brady's success was also due to his shrewd ability to find talented camera operators. Brady's dimming eyesight made it difficult for him to operate the camera personally. The daguerrean journals noted his inability, but gave him full credit for promoting the work of the gallery. Often the camera operators who got their start under Brady opened their own galleries after acquiring skills and a reputation at Brady's.

Modern art critics have downgraded Brady's contribution because other men operated his camera. Brady would have been puzzled by this judgment. It was perfectly acceptable for him, as the owner of the gallery, to take credit for work done there. The great artists of the past worked with studios and assistants who did some of the work. It was Brady, the testimony of his contemporaries shows, who insisted on first-rate work at all times.

It is the subject matter, selected by Brady, that makes him important for us today. He had a passion for photographing history—a passion that was evident from the very beginning. Brady recorded for posterity practically all the notable American men and women from 1844 on. Brady's most famous achievement—other than making his Civil War photographs—was taking the picture of every American President but one, from John Quincy Adams, who served from 1825 to 1829, to William McKinley, who took office in 1897.

An interviewer asked Brady toward the end of his life about his interest in historical figures. The answer was that to Brady the famous men and women who sat before his camera were not musty figures in a history book. They were living people who were exciting because of their achievements.

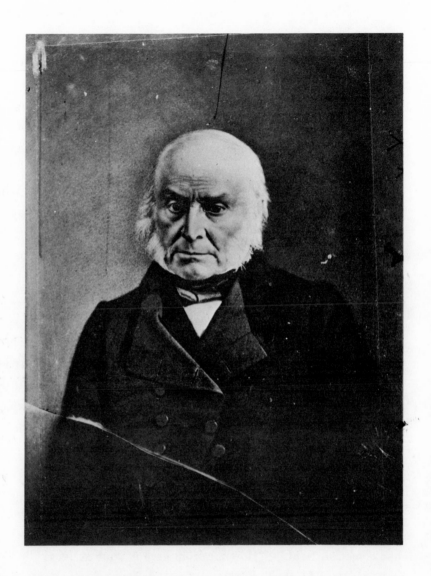

John Quincy Adams, sixth President of the U.S., was the earliest president to be photographed for Brady's collection. Although he left office in 1829, Adams lived until 1848, allowing time to have his likeness recorded for the camera.

"All men were to you as pictures?" the interviewer asked Brady.

"Pictures because events," the old photographer reminded him.

How Brady began his career of photographing history is unknown, but once he started, he let nothing stand in the way of getting his picture. He heard Andrew Jackson was close to death in his home in Tennessee. Brady sent a man to capture Jackson in the last daguerreotype of the seventh president.

President Polk recorded his appointment with Brady in the White House on February 14, 1849, for what was probably the first daguerreotype ever made of a President in his official residence. Brady's photograph, taken in May of the same year, of Zachary Taylor and his cabinet was the first daguerreotype ever taken of a President with his cabinet officers.

Politicians were not the only persons Brady photographed. Years later he recalled "being much perplexed to know how to get Fenimore Cooper," the famous author of *The Last of the Mohicans* and *The Deerslayer*. Cooper avoided daguerreotypists; rumor had it that one had so irritated him that he stalked from in front of the camera and out of the gallery. Brady recalled his own approach to Cooper: "I never had an excess of confidence, and perhaps my diffidence helped me out with genuine men."

Brady went to the New York hotel where Cooper was staying. In Brady's words, Cooper "came out in his morning gown and asked me to excuse him until he had dismissed a caller. I told him what I had come for. Said he, 'How far from here is your gallery?' "

"Only two blocks," Brady replied, and "he went right along, stayed two hours, had half a dozen sittings." One of Brady's daguerreotypes was obtained by Cooper's publishers to serve as the model for a painting they wanted done. And another figure was added to Brady's growing collection.

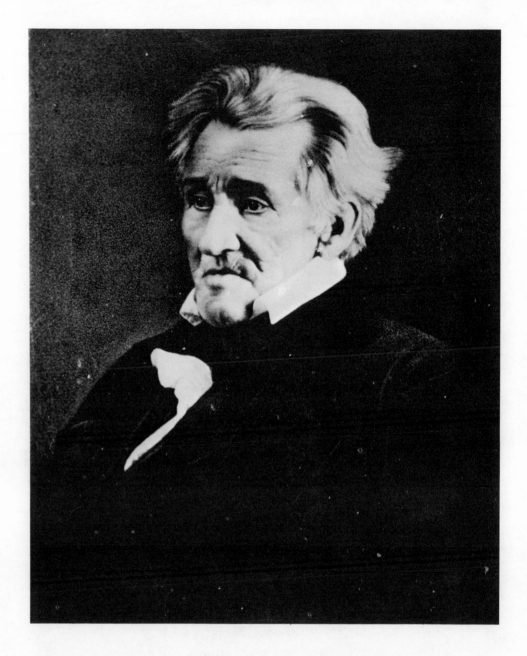

This daguerreotype of Andrew Jackson, seventh President of the U.S., is said to be the last ever taken of him.

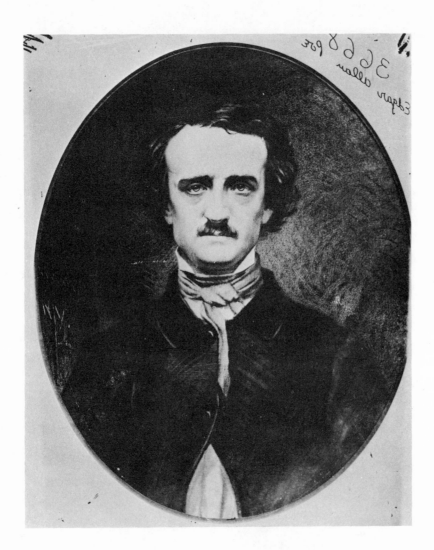

Edgar Allan Poe, as he appeared in the lithograph used in Brady's *Gallery of Illustrious Americans*. Many years later, Brady recalled making a daguerreotype of Poe, which he later copied using the collodion process. The collodion negative was used to make many copies of that portrait.

Edgar Allan Poe was another elusive subject. "I had great admiration for Poe," Brady said, "and had William Ross Wallace bring him to my studio. Poe rather shrank from coming, as if he thought it was going to cost him something." But Brady fixed the haunted eyes of the author of macabre tales through the camera lens and recorded them for all time. "Many a poet has had that daguerreotype copied by me," Brady said with pride.

Brady was skilled at attracting publicity for his gallery, but he was an amateur compared with the master showman P. T. Barnum. In 1850 Barnum brought the famous singer Jenny Lind to the United States for a series of performances. Jenny Lind was renowned for the beauty of her face as well as the loveliness of her voice. Barnum's advance ballyhoo made her the nineteenth-century equivalent of a superstar. She opened in the Castle Garden in New York City for the unheard-of salary of one thousand dollars a night. Every daguerreotypist in New York was clamoring for her portrait. Barnum shrewdly bided his time, keeping Jenny Lind under close wraps, waiting for the right offer.

Brady outsmarted Barnum by finding an inside track. A man came to his studio for a portrait and happened to mention that he had known Jenny Lind when they were schoolchildren in Sweden. "He got me the sitting," Brady gleefully remembered.

Jenny Lind was fascinated by the pictures of the famous displayed on Brady's walls and stayed for hours instead of the few minutes Barnum had allowed her. By the time she was ready to leave, a crowd had gathered outside the gallery. The mob pressed against the downstairs door, eager for a glimpse of the famous Swedish Nightingale. Brady and his assistants spirited her out a rear door to a waiting carriage.

In 1849 and 1850 Brady obtained the portraits of three of the

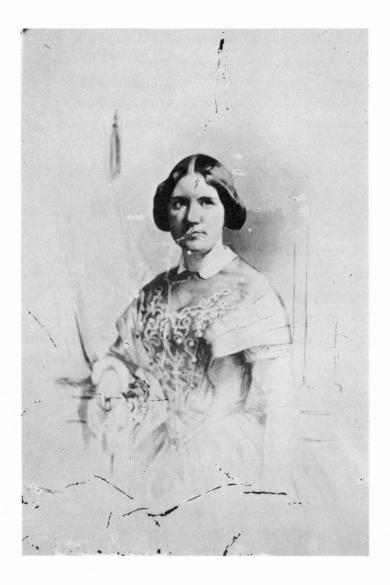

Jenny Lind, the "Swedish Nightingale." Brady's *carte de visite* photo of her was duplicated thousands of times to satisfy the curious public who couldn't buy a ticket to see her in person.

greatest Americans of the time—Henry Clay, John C. Calhoun, and Daniel Webster. The daguerreotypes of the three great orators and statesmen took their places, retouched with ink and paint, on the walls of Brady's gallery, where his growing collection was displayed. Customers waiting their turn to be photographed passed the time by admiring the images of the famous men and women. Brady soon noticed that he was attracting customers who came just to see the likenesses displayed on his walls.

An additional income developed when engravers for books and magazines sent to Brady for copies of his daguerreotypes when they wished to make an engraving of a famous person's face. It was impossible at the time and for many years after to make a printed copy of a daguerreotype by direct means. Engravers used daguerreotypes as models for their hand-engraved work.

The added business convinced Brady that a collection of his famous pictures would be successful in book form. He announced plans for the publication of *The Gallery of Illustrious Americans*. This would not be an ordinary book of portraits. Brady's insistence on quality would make it an extravaganza. It would be a collection of lithographed portraits and biographies of twenty-four of "the greatest Americans since the death of Washington."

The *Gallery* would be issued in two parts. The names of the first twelve Americans Brady selected shows us something about his feeling for what was important in the achievements of the famous. There were two Presidents, Zachary Taylor and Millard Fillmore; three senators, Clay, Calhoun, and Webster; an explorer, John C. Fremont; a historian, William H. Prescott; a clergyman, William Ellery Channing; a naturalist and painter, John James Audubon; a general, Winfield Scott; a presidential candidate, Lewis Cass; and a political leader, Silas Wright. Politicians predominated, but Brady was sensi-

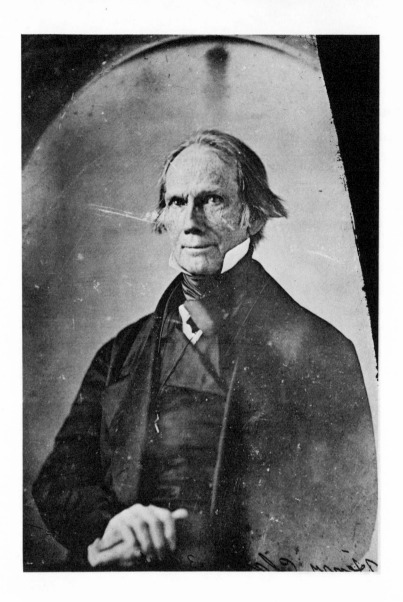

Henry Clay, honored Senator and statesman from Kentucky, helped to hammer out the Missouri Compromise of 1820, which kept the Union from an early division on the question of slavery. A similar crisis in 1850 was also resolved by a plan offered by Clay, earning him the name, "The Great Compromiser."

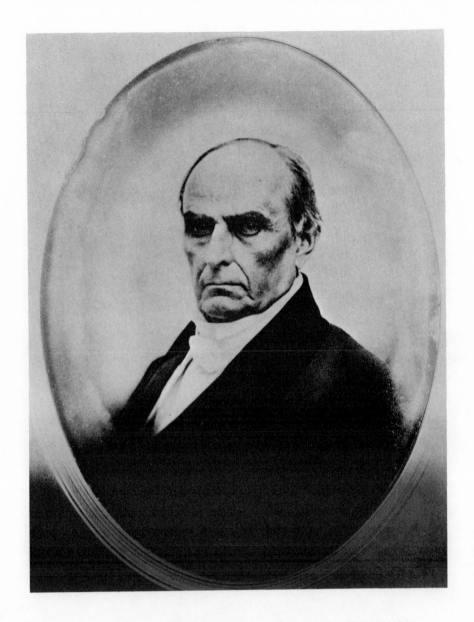

Brady's daguerreotype of Daniel Webster who, with Clay and Calhoun, occupied a place of honor on the walls of Brady's gallery. Webster was a New Englander who called slavery a "great moral and political evil."

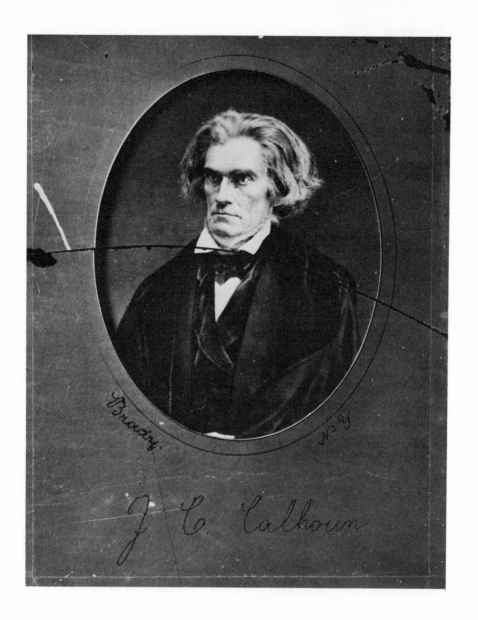

John C. Calhoun, a Senator and statesman from South Carolina who fought for states' rights. His views were respected, although his defense of slavery and call for Southern independence rather than Federal control contributed to the Civil War.

tive to the arts and letters as well. More significantly, his selections represented a cross section of the nation geographically. A split between North and South was already widening, and Brady bridged the gap in his choice of figures.

The book was ambitious in size, with large pages expensively printed and bound. Brady paid Francis d'Avignon one hundred dollars an illustration to make the lithographs, and biographies accompanied the portraits. The first volume, published in 1850, was a magnificent book weighing more than five pounds and stamped in gold leaf on brown leather binding. It sold for thirty dollars a copy, and the price put it out of reach for all but the wealthy. The book did not sell well, and the second volume of twelve illustrations did not appear.

Brady lost money on the project, but he made up for it in prestige. When the press or public wanted photographs of the famous, increasingly they turned to Brady. And those who wanted to be photographed by the man who took the pictures of illustrious Americans came to Brady. Two dollars was a small price to pay for being immortalized in silver and mercury. No matter who the operator behind the camera was, the result still bore the well-known imprint "Photo by Brady."

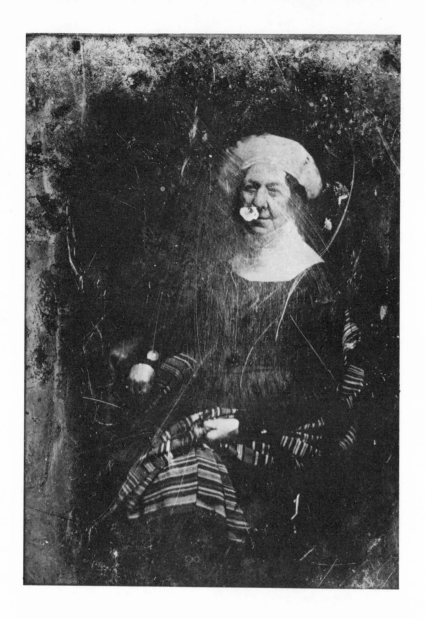

Dolley Madison, wife of James Madison, the fourth President of the U.S. With this portrait, Brady provided a link with the earliest days of the American republic. In the 1840's, she was still a leading force in Washington society.

THE CRYSTAL PALACE

IN 1847 Brady set up a temporary gallery in Washington for photographing the politicians and their wives who were living in the capital city. Dolley Madison, the wife of the nation's fourth President, sat for Brady's camera. The photograph shows a serene old lady of eighty years, much more subdued than the vivacious belle who had been the queen of Washington society.

Mrs. Alexander Hamilton was another who fell captive to the daguerrean art of Brady. With these figures he preserved some link with the very earliest of the country's leaders. He even extended farther back his chain of presidential history when he photographed Rembrandt Peale, who as a youth of eighteen had painted George Washington from life.

Brady began traveling to Washington more frequently. In 1849 he opened a public gallery there for the first time, but later vacated the premises in a dispute with his landlord. Back in New York trusted assistants capably ran the Broadway gallery while Brady added to his portraits of famous men and women.

While on one of his trips to Washington, Brady was invited by a

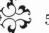

friend to a ball at one of the lavish Southern homes in nearby Maryland. Brady was awkward and shy about social gatherings despite his business success. Nonetheless, he accepted the invitation, and that night danced with the daughter of the rich Maryland homeowner. Her name was Julia Handy. She and Brady fell in love.

We have no details of their courtship. A picture of Julia with Mathew shows a delicate southern belle with long dark hair fixed in ringlets, her soft dreaming eyes looking toward the side. Her beau, the famous daguerreotypist, has removed his thick glasses for the portrait. He has, by the late 1840s, begun to affect a mustache and goatee. His pose is almost self-consciously gallant with one hand tucked tentatively into the flap of his coat and the other resting protectively around the shoulder of his beloved Julia. Their marriage took place in the late 1840s or early 1850s.

The winter of 1850–51 was a severe one. Brady's health suffered. He had been working hard, traveling to find more pictures and working to establish a permanent gallery in Washington where he and Julia had taken up residence in the National Hotel. Brady's younger brother, John Andrew, had come to New York to find work as a jewel-case maker. Brady no doubt put him to work in the New York gallery, making daguerreotype cases. But John fell seriously ill, and Brady's concern for him added to the strain.

Finally, Brady's eyes seemed to be fading even more. He carried several pairs of glasses; none of them helped much. He still employed skilled operators, but he regretted his growing inability to handle a camera himself.

He still enjoyed the thrill, which never palled, of watching over the final stage of the daguerreotype development as "nature did her work" and the finished picture appeared on the blank silver plate. After seeing this process "upwards of 20,000" times, Brady remem-

A daguerreotype of Brady with his hand on the shoulder of Julia Handy, his future wife. The woman on the right, a Mrs. Hagerty, is thought to have been Julia's sister.

bered, he "never grew so familiar with the process not to feel a new and tremendous interest in every repeated result."

But a new opportunity arose. Britain's Queen Victoria and her husband Prince Albert announced plans for a great exposition of artistic and industrial products from all over the world. At a cost of nearly a million dollars, a truly fabulous sum, they planned to build a Crystal Palace in London's Hyde Park to house the great exhibit. It was to be the first World's Fair. Prizes were offered for every category of art, craft, and manufacture—including daguerreotyping.

New York was abuzz with the news. Some daguerreotypists placed ads in the newspapers, looking for bizarre subjects. Freaks, Revolutionary War veterans, twins, and triplets were among the "desirable" subjects. Brady knew better. Quality was what he dealt in—quality of work and the plain faces of history. For months he worked assembling the entry that he would take to the World's Fair. At last he settled on forty-five daguerreotypes of the famous and talented persons who had posed for his camera.

Julia and Andrew sailed for England in July, 1851. Their companions aboard ship were James Gordon Bennett and his family. Bennett was the dynamic founder and editor of the New York *Herald*. He had originated many of the journalistic traditions of America— the Wall Street report, the spectacular murder case coverage—and Brady had often tried without success to get him to sit before the camera. Only later did Brady capture a group picture of Bennett and his staff.

They and millions of other visitors from the world over found the Crystal Palace to be the showplace of Victorian England. The glass-enclosed exhibit had a floor area of more than 800,000 square feet. The Palace itself was a third of a mile long, with over eight miles of

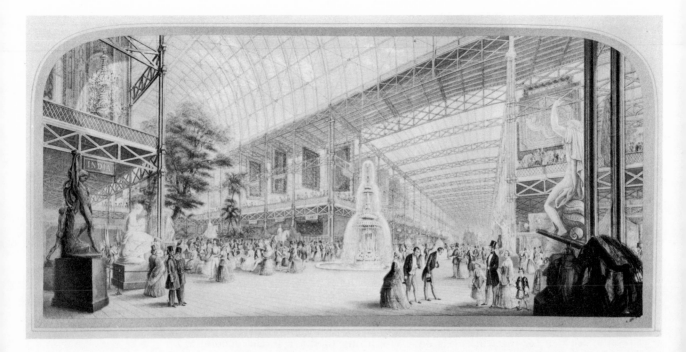

The Crystal Palace, the great exhibition hall built in London's Hyde Park for the Exhibition of 1851. More than 13,000 exhibitors from all over the world sent or brought their works for the first world's fair. In the following decade, the Crystal Palace served as a model for exhibition halls at similar fairs in Cork, Dublin, New York, and Munich. More than 6 million visitors came to the original Crystal Palace fair.

display tables. More than 13,000 exhibitors sent entries. Representing the United States were industrial products such as false teeth, artificial legs, Colt pistols, Goodyear rubber, chewing tobacco, the McCormick reaper, and the daguerreotypist's art.

When the time came for the awards in daguerreotyping, the French waited expectantly. After all, their national pride was the invention of the great Frenchman Daguerre, who had died only that year.

But three of the five silver medals for first place went to Americans. Martin Lawrence of New York won for his large-size allegorical portrait of three young women, titled "Past, Present, and Future." John Whipple of Boston won for a detailed daguerreotype of the moon taken through the telescope at Harvard College Observatory. And Mathew Brady won a silver medal for the general excellence of his entire collection.

What a triumph for Brady! The London newspapers were full of praise for his work. His new wife along to share in the accolade, he stood in the greatest city in the world acclaimed as the greatest practitioner of his art.

When news of the prizes reached New York, there was jubilation. Horace Greeley, the editor of the New York *Tribune*, proclaimed, "In daguerreotypes, we beat the world." That was the general sentiment. Daguerreotyping—photography—was now an American art form. The London papers agreed.

For months afterward Mathew and Julia toured the great cities of Europe. In England he took the portraits of a cardinal and an earl. In Paris French writers took their turn before his camera, while a colleague of Brady's photographed the Emperor Louis Napoleon. At the Pitti Palace in Florence, home of some of the world's greatest art treasures, Brady found that the gallery had already obtained one of his daguerreotypes for its collection.

The journey through Europe was one of the happiest times in Brady's life. New photographic techniques—the collodion process, the talbotype—were exhibited at the World's Fair, and Brady keenly sensed their value. New challenges and opportunities lay ahead. The future looked very bright to Julia and Mathew Brady.

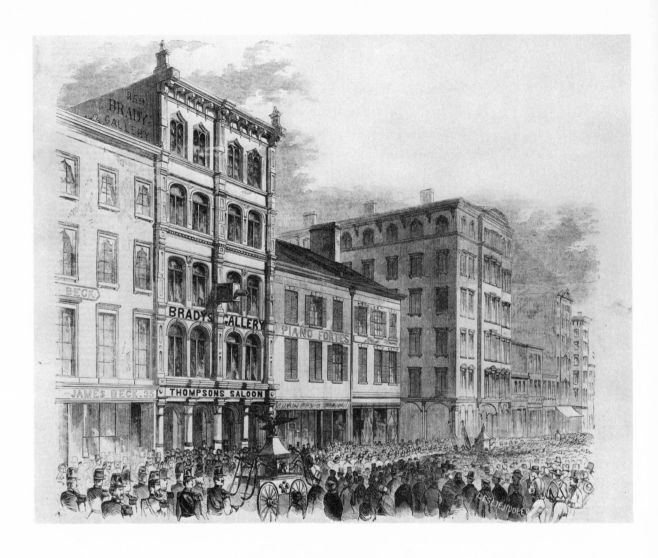

The exterior of Brady's Tenth Street gallery in New York, opened in 1853. The move uptown kept pace with the northward growth of the city. The gallery fronted onto Broadway, and in the engraving shown here, a Firemen's Parade is passing by on New York's main thoroughfare.

BRADY OF BROADWAY

JULIA and Mathew returned to the United States in May of 1852. There was sad news. Brady's brother, a young man of only twenty-two, had died in their absence. But the gallery, which Brady had left in the hands of George S. Cook, had prospered. Brady's London triumph had increased the demand for a portrait "by Brady."

In 1853 New York built its own Crystal Palace for a World's Fair. Smaller in scale than the grand London showcase, one aspect of the New York fair was the same: Brady took first place for daguerreotypes.

But Brady wasn't about to rest on his laurels. New York had been growing rapidly. Brady's original gallery had been at the center of town. Since its opening, the city had moved northward, expanding into the area of Manhattan that had been farmland. In 1852 a committee recommended that the area now known as Central Park be set aside for public use. Brady, shrewdly looking ahead, purchased some land adjacent to the park area for possible development.

In 1853 Brady opened his second gallery at 359 Broadway, above Thompson's Saloon. The demand for daguerreotypes had never been

greater. It was estimated that two million were being made in America every year. New competitors were springing up almost daily. Their chief attraction was lower prices and quicker service. New technology made it possible to reduce the time for a sitting to a few seconds.

Brady, as always, took the high road. His new gallery catered to the public taste for lavish, elaborate furnishings. At the downstairs doorway specimens of Brady's work were exhibited in rich rosewood and gilt showcases. Two flights up were the reception rooms where customers placed their orders and waited for their sittings. Cut-glass folding doors were at the entrance to these rooms.

The main waiting area was about twenty-six by forty feet, with floors covered with a velvet tapestry. The walls were covered with satin and gold paper. The ceiling was painted with frescoes, and in the center of the room hung a gilt and enameled chandelier with crystal drops that threw colored light along the walls. Lace curtains covered the windows. Rosewood furniture—straight chairs and easy chairs and marble-top tables—adorned the room. At strategic places along the walls full-length mirrors seemed to increase the size of the room. But on the walls themselves, against the lush paper, were Brady's real glories—daguerreotypes of Presidents, generals, kings, queens, and men and women from all nations and professions. A special parlor for ladies was no less sumptuous.

When a customer's turn came, he or she was ushered upstairs to one of the two operating rooms, one with a northern and one with a southern exposure. Most of the daguerreotyping was done in the morning, when light was best. On cloudy days the need for longer exposures often caused the number of people waiting for their sittings to back up. They whiled away the time in the sumptuous waiting rooms.

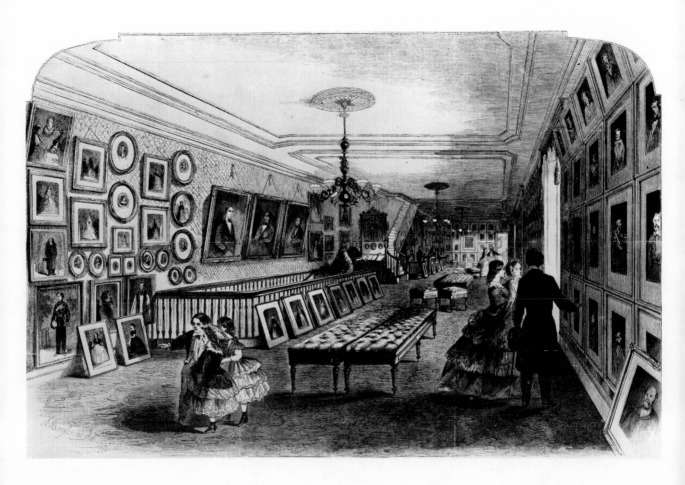

The interior of the Tenth Street gallery, showing the lavish furnishings and the exhibition of portraits of famous men and women that covered the walls. This engraving appeared in *Frank Leslie's Illustrated Newspaper*, which used many of Brady's portraits as models for its engravers to copy.

The gallery also included business offices, a plate-cleaning department, an electrotype room, and a chemical room where the technical operations were carried out. It was a gallery reflecting wealth, the rococo taste of the age, and altogether appropriate for the premier photographer of New York society.

Still, though every New Yorker who wanted his or her picture taken might have thought of Brady's, not all could afford it. They might come by to look at the famous gallery, but more and more they were drawn to the cut-rate galleries. Competitors were offering daguerreotypes as low-priced as two for twenty-five cents, which were of a much smaller size than Brady's gallery was accustomed to making. Brady responded with newspaper ads appealing to the public's taste.

The public made its choice, persisting in preferring the cheap work, rather than the finely crafted work of Brady. Eventually Brady was forced to offer reduced-size, reduced-price daguerreotypes.

Two developments breathed new life into Brady's business. One was the invention of the collodion, "wet-plate" photographic process. The other was the arrival of Alexander Gardner.

An Englishman named Fox Talbot had earlier found a way to produce a negative image on paper that could be used to make any number of positive prints. The foremost artists of the "talbotype" were D. O. Hill and Robert Adamson of Scotland. Their prints are looked on with great favor by the art critics of today. Brady, if he saw them, must have remarked at the graininess and lack of clarity that the talbotypes had, compared to the razor-sharp daguerreotype.

But another Englishman named Scott Archer developed a process using a chemical mixture called collodion which resulted in a negative image on glass. From this sharp glass negative any number of positive copies could be made, and their sharpness was far better than that of the talbotypes. Use of the collodion negative eliminated the

difficulty of making duplicates of daguerreotypes. Similar to the photographs of today, collodion positives were made on dull-finish "salt paper." Sometimes, the collodion negative itself was mounted in a frame under glass with a black backing of metal or paint and viewed in the same way as a daguerreotype. Negatives mounted in this way were called ambrotypes. Because the collodion glass plate had to be freshly coated and sticky when inserted into the camera, collodion photography became known as the "wet-plate" process.

The first American photographers to make commercial use of the new process were Whipple of Boston and James A. Cutting. Brady was not long in seizing on the advantages of the collodion print, however. By 1854 he was making collodion prints in his New York galleries. Austin Turner from Boston and L. E. Walker were two of his early collodion operators. Both had established reputations in the field before they came to work for Brady. Turner had been the operator for Whipple, the Boston daguerreotypist who shared the honors with Brady at the Crystal Palace Exhibition.

Around the same time, in the mid-1850s, another wet-plate operator arrived in New York from Scotland. This man was Alexander Gardner, who joined Brady's gallery in 1856.

Gardner was a brilliant, energetic man who had experimented with various scientific processes in Great Britain. His ideas for a utopian society had been adopted by British settlers who founded communities in Iowa. Many of Gardner's relatives had joined the Iowa communities, but his urge for scientific experimentation had kept him behind. He was an early worker with the collodion process in England. It has often been speculated that Brady met Gardner in London at the Crystal Palace Exhibition.

However they met, their collaboration was important for American photography. Almost at once Gardner brought innovations to

Brady's studio. As always, Brady recognized the value of another man's talent and provided the support for Gardner's work. It should be added that he reaped the benefits from it as well.

Gardner began making enlargements of the collodion negatives, projecting them onto paper positives to increase their size. Almost all modern photography is based on the enlargement method, but it was a startling innovation in the 1850s. Defects in the plate that were exaggerated by the enlarging process were covered up by the use of crayon, paint, or ink on the finished print. Brady began offering these enlargements to the public as "imperial photographs." Although one scoffer said the only thing imperial about them was the price— which could run to hundreds of dollars for a single print—they once again brought Brady of Broadway to the public eye.

Brady's competitors took up the new technique, vying to see who could make the largest imperial. Soon they were being offered in sizes such as 5 x 7 *feet* and at prices that ranged up to $750. Gardner outdid them all, however, and Brady hung three transparent portraits (one of them of his old mentor Samuel Morse) on a screen 50 x 25 feet outside his gallery and lighted it from behind with 600 candles. New York came to gape and stayed to have more modestly sized daguerreotypes or ambrotypes made "by Brady."

Brady was ready now to open a permanent gallery in Washington. He had the man for the job. The gallery opened in 1858 with Gardner in charge. It was grandly named the National Photographic Art Gallery and it featured many of the same attractions as the New York galleries. Copies of the daguerreotypes of the famous and powerful had been made to hang on the walls of the entrance halls and waiting rooms. Citizens of Washington, like those of New York, flocked to see the famous faces.

Gardner, more businesslike than Brady, kept careful records of the

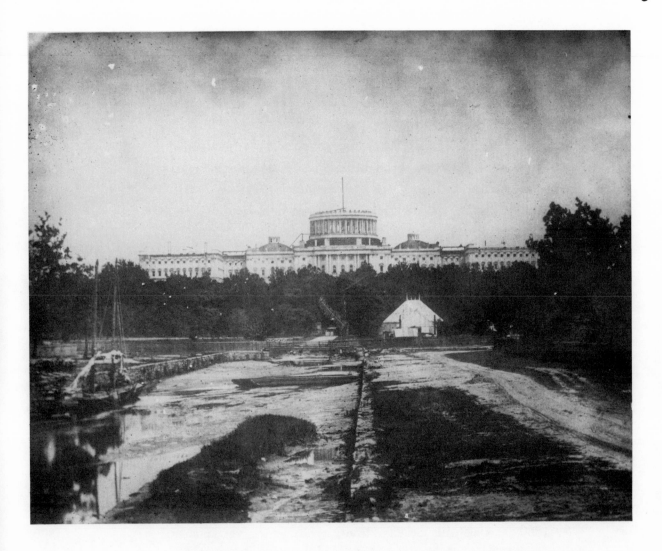

Around 1858, Brady's studio photographed the construction of the new Capitol building in Washington, D.C. In this picture, the dome has not yet been built. The canal in the foreground is a reminder of the fact that the land on which the capital city was built was originally a swamp.

income and expenses of the gallery. From these we learn that operators were paid $11.00 per day, or $16.66 for Sunday work. (Considering the inflation of the dollar, that was the equivalent of about $20,000 annually today.) Women employees who mounted and framed the pictures received $8.00 a week.

The reception room of the Washington gallery held a large wooden box with eyeholes. Those who peered inside could see a three-dimensional image, often of a New York or Washington street scene. Different scenes appeared as one turned a knob on the side of the box. The fascinating device was a stereoscopic viewer.

Mounting daguerreotypes in pairs and viewing them through a binocular lens for a three-dimensional effect had been practiced for some time. But the paper prints made from the collodion process were easier to mount and duplicate for stereo viewing. The stereo craze that would sweep the country in the years between the Civil War and 1900 was just beginning. Eventually every home would have a stereo viewer and box of cards. But the one at Brady's was still a novelty.

The sensation that the stereo views caused in customers who looked at them was not missed by Brady. He purchased stereo cameras and began making three-dimensional views that could be reproduced by the thousands on stereo cards. Many of his Civil War photographs would be stereos.

By 1860, moving with the city, Brady was opening yet another gallery in New York, further uptown again, at the corner of Broadway and Tenth Street. On that occasion the writer for the New York *Times* put into words the fascination of Americans with having their pictures taken:

Brady has reappeared on a scale and after a fashion which strikingly illustrates the development of photography into a

colossal industry worthy to take its place with the most significant manufactures of the country. The prosperity which makes such an establishment possible . . . throws a marvelous light upon the means which we shall bequeath to our posterity of knowing what manner of men and women we Americans of 1860 were. All our books, all our newspapers, all our private letters . . . will not so betray us to our coming critics as the millions of photographs we shall leave behind us. Fancy what the value to us would be of a set of imperial photographs of the imperial Romans! How many learned treatises we would gladly throw into the sea in exchange for a daguerreotype of Alexander the Great, or an ambrotype of Cleopatra as she looked when she dropped that orient pearl into her cup with sumptuous grace!

Well, these we shall never have, but in default of them, our children's children may look into our very eyes, and judge us as we are. Perhaps this will be no great advantage to us, but in our children's children's name, we ought to thank Mr. Brady and those who labor with him.

Through the waiting rooms of all three of his galleries stepped the rejoicing, strutting Brady, greeting favored customers, flattering the ladies, guiding a society figure over to the latest addition to his gallery walls. Brady especially enjoyed a visit from his friends in the entertainment world. Many of his photographs show actors and actresses in costume. Brady, accompanied by his wife, enjoyed a night at the theater with perhaps a glass or two backstage with his friends after the performance.

Brady was a smartly turned out figure, even a dandy, the picture of the successful artist. He wore a black coat, black doeskin pants, and a knitted vest of finest merino wool, all tailor-made for him. He wore muslin shirts and silk scarfs, and carried linen handkerchiefs and a cane. He washed with perfumed soap and splashed on a little

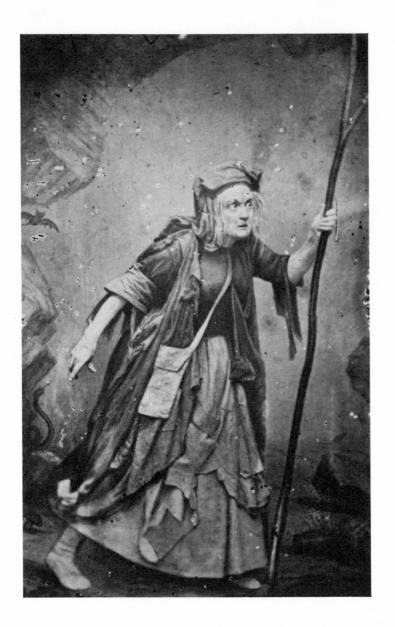

Brady had many friends in the theater and arts. Charlotte Cushman, shown here, was the foremost American actress of her time. In this Brady picture, she is seen as Meg Merrilies in the play *Guy Mannering*. She also played men's roles such as Hamlet throughout the United States and Europe before retiring in 1870.

Atwood's cologne in the morning—a man meeting the public had to be careful about the impression he gave. The public expected an impressive figure of Brady of Broadway.

A poem by the famous Western American writer Bret Harte tells us something about the reputation Brady had across the country at this time. Some of the verses go:

> If you saw papa's picture, as taken
> By Brady, and tinted at that,—
> You'd never suspect he sold bacon
> And flour at Poverty Flat.

The presidential candidates in the year 1860 dutifully came by to have their likenesses recorded at Brady's. Lincoln was not the first or the last. Brady had photographed Stephen Douglas, Lincoln's old foe, as early as 1845. Douglas came by again in 1860 for his campaign portrait.

There were calls for pictures of all the campaigners. The illustrated magazines with national circulations, *Leslie's Illustrated Newspaper* and *Harper's*, depended heavily on Brady for portraits that their engravers could copy. In the year 1856 *Leslie's* used 123 illustrations that had been copied from photographs or daguerreotypes. Of these, ninety-seven were credited to Brady's gallery.

Even more important than the presidential candidates, however, was the prince who was coming to New York. The Crown Prince of England, Victoria's son, the future Edward VII, was touring the British dominions in Canada in October, 1860. He and his party announced plans to visit New York, making the first visit of British royalty to the late colonies, now the United States.

New York turned out in force to welcome the prince. A torchlight parade and a gala ball marked his arrival. As with Jenny Lind, the photographers of New York began laying plans to capture the

prince's likeness. The new photographic fad was the *carte de visite*, a paper photograph on a card about 2½ x 4 inches. Cartes de visite of celebrities were much in demand for the albums in which families collected them, often alongside cartes of family members. Cartes de visite of the prince were sure to be a bonanza for any photographer who could supply them.

On October 16, 1860, the prince and his entourage left their Fifth Avenue hotel in carriages. Crowds, seeing the plumed horses of the royal carriage, set out to follow them, cheering and waving to the delighted young prince, who waved back.

The carriages turned into Tenth Street and stopped at Brady's studio. Brady was waiting to guide the prince personally through the gallery. No different from anyone else, the prince paused to examine the famous faces on Brady's walls. Then the operating room was opened to the prince and he sat for his imperial, first alone, then with members of his party. Brady, to be sure, was quick to have a few carte-de-visite photos taken as well.

The laboratory quickly developed the pictures of the prince, and he looked at them with satisfaction. He also ordered several copies of the photographs of the more prominent Americans on display, asking for one "immediately" of President Buchanan and his cabinet. Then Brady proudly produced his register of guests for the prince to sign.

Brady accompanied the royal party out to the street, where their carriages were waiting. The crowds pressed all around to see the prince shake hands with Brady and once again extend his compliments on the excellence of Brady's collection. The carriage horses stepped off smartly, and Brady stood in Tenth Street, basking in the admiration of the crowd. "You see who the prince came to?" someone might have said. "That's Brady. Brady of Broadway."

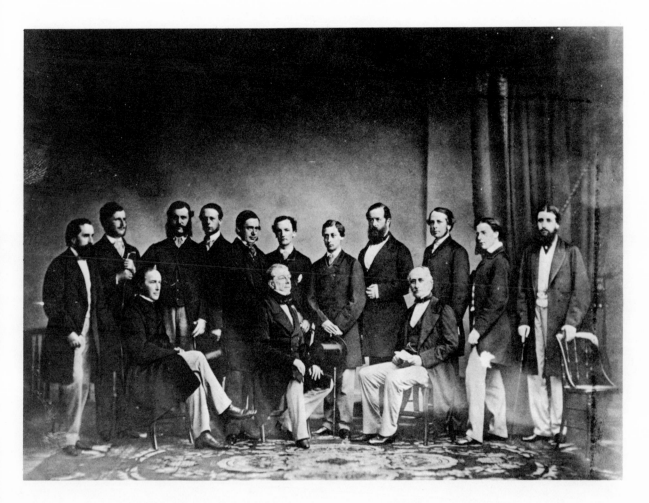

The Prince of Wales (standing, fifth from right) with the royal party that accompanied him to New York. The future Edward VII of England would later give his name to the Edwardian Age between 1900 and the beginning of World War I. Notice the family resemblance between Edward and the present-day Prince Charles, his great-great grandson.

74

Brady recalled later that he managed to ask the Duke of Newcastle, one of the prince's escorts, why they had chosen to come to his studio. The duke replied, "Are you not the Mr. Brady who earned the prize nine years ago in London? You owe it to yourself. We had your place of business down in our notebooks before we started."

Later the prince sent Brady and his wife mementoes of the occasion. For Brady he sent a handsome ring and a rosewood cane with an ivory handle and the inscription "M. B. Brady from Edward, Prince of Wales."

"MY FEET SAID GO"

BRADY was at the zenith of his career. His exclusive session with the prince had cemented his reputation as the photographer of society. His cartes de visite and stereo views also sold well, keeping him in touch with public taste and popularity.

But the nation faced its darkest moment. The election of Lincoln —whose views were unacceptable to the South—seemed to ensure the secession of the Southern states. On December 20, 1860, South Carolina had held a convention in Charleston, voting unanimously that South Carolina should secede from the Union. Six other states followed suit by February, the month before Lincoln's inauguration. On February 8, a new nation, the Confederate States of America, was born. Jefferson Davis was selected President. Waiting for Lincoln's inauguration, Confederates and Federals held their breath.

Brady was busy. Politics was a part of history and, for him, something to be photographed. Washington was the place to be. Rumors of assassination attempts on Lincoln were rampant. Washington, located between two Southern states, one of which had seceded, was alive with intrigue. The National Hotel, where Brady and his wife

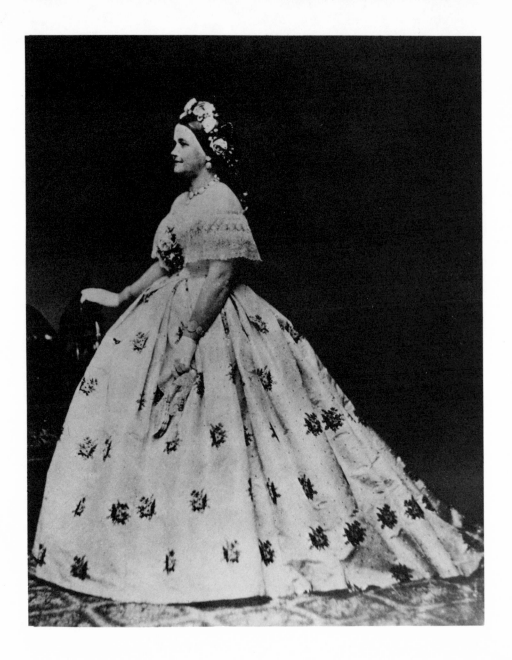

Abraham Lincoln's wife, Mary Todd Lincoln, in one of the four
gowns she wore to inaugural balls in 1861.

stayed, was a hotbed of Southern sympathizers. Brady eagerly collected the photos of those who would serve North and South alike—as officers, politicians, and spies. Mrs. Lincoln, aware of her new social position, came to Brady's Washington gallery to have her photograph taken in her Inaugural Ball gown.

Lincoln's inaugural was held under tight security. Brady used his political contacts and obtained from General Meigs, chief of security, permission to photograph the inaugural. Brady and Gardner arrived at the Capitol at dawn. They set up their camera and darkroom on a platform overlooking the scene. Pinkerton agents, hired to protect Lincoln, looked them over warily. Nothing could be more suspicious than the black-cloaked tent that was needed to prepare and develop the collodion plates.

Around noon President Buchanan and President-elect Lincoln arrived for the ceremony. Brady and Gardner took the freshly prepared plates from their assistants in the tent, quickly recording as many shots as they could. The inaugural went on without a hitch. Lincoln's speech made it clear that he would "hold, occupy, and possess" the property of the Federal government in the South—specifically Fort Sumter, a Federal fort near the mouth of Charleston Harbor, South Carolina.

The Confederacy was not long in acting. April 12, 1861, the first Confederate shells fell on Fort Sumter. After a fierce fight the Union commander evacuated the garrison. The South seized all Federal arsenals, customs offices, shipyards, and post offices in the Confederate states.

Lincoln responded by calling 75,000 volunteers to put down the rebellion. Enthusiasm ran high. Like all wars, this was to be a short and easy one. Volunteers came streaming into Washington, itching for a shot at Johnny Reb. As each man was issued a uniform, he

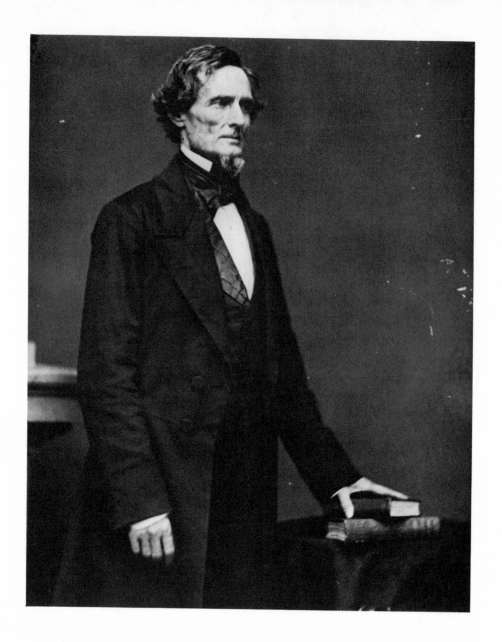

Jefferson Davis, president of the Confederacy. Brady's studio photo-
graphed him before the war, when he had been a member of
Congress and Secretary of War.

rushed to a photographic studio to have his picture taken for the folks back home. Brady's gallery, like the others in town, was doing a land-office business in cartes de visite. Tintypes, which were collodion-base pictures made on thin sheets of metal with a black base, were also very popular because they could be mailed home without danger of damage.

But Brady was restless. Cartes de visite, even in his gallery, were taken on a mass-production basis. The usual camera had four or six lenses for taking a number of negatives at a single sitting, resulting in prints for twenty-five cents or less. Brady wasn't interested in mass-produced photographs. There was no challenge, no quality in them.

History beckoned. Up to now history could be served in a plush, comfortable gallery with plenty of talented assistants preparing plates, taking pictures, and developing them for Brady. But other men had gone afield after history.

Brady himself had made copies of the remarkable daguerreotypes that S. N. Carvalho had made of the Fremont expedition that explored the West. Carvalho had carried his bulky equipment across the continent, fording rivers and scaling the Rocky Mountains with it. When starvation and illness ravaged the exploring party, Carvalho abandoned the equipment in the snows of the Rockies and made his way back to civilization, clutching the precious daguerreotypes that Brady copied onto glass plates.

There were even pictures of earlier wars. A few daguerreotypes showed troops in the Mexican War of 1848. Some of the greatest war pictures had been taken in the Crimea in 1855 by the English daguerreotypist Roger Fenton.

Brady knew that history was shifting from the gallery to the battlefield. And it should be recorded, not piecemeal as Fenton had done it, but completely, as only Brady of Broadway could do it.

He would turn his entire staff over to the war effort, have men on all the fronts, on every campaign, to make something unique: a complete record of a war, of war itself, with all its horrors and glories for the world to view. It would be the greatest achievement any photographer had ever accomplished.

But when Brady confided his intentions to his wife and friends, they were horrified. What of the business? What of his reputation? And to think that Brady planned to go *himself*? With his failing eyesight and poor health? The dandy of Broadway, used to the comfortable life, carrying the cumbersome equipment under enemy fire and through the mud and gore of the battlefield? Impossible!

But Brady had a vision that would not be denied. He went to an old acquaintance, General Winfield Scott, head of the army. Scott confided that he was soon to be replaced as active commander. Perhaps the new commander, General Irvin McDowell, would be of help. Or Secretary of War William Seward. Brady made the rounds and found the same disbelief that his family and friends had shown. Certainly no one in the government was willing to provide funds for such a venture. Perhaps they thought it was a publicity stunt. The society photographer Brady wanting to photograph the war? Preposterous!

Brady went to see Allen Pinkerton, chief of Lincoln's security. Pinkerton shrugged. A harmless request. If Brady wanted to throw himself before the guns of both sides, let him. But he could expect no protection from the government.

Brady knew the workings of the powerful. Lincoln owed him a favor. Lincoln had said as much. Very well, he must see Lincoln.

Lincoln never said what he thought of Brady's war work. He may have been amused by the little man who came to his office with such an unusual request. He may have admired Brady's determination. He may have seen a spark of greatness in Brady and his vision. Lin-

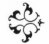

General Winfield Scott, commander of the Union forces at the outbreak of the Civil War, was replaced before the fighting began.

coln took a heavy card from his desk. He wrote "Pass Brady. A. Lincoln" on it, and handed it to Brady. Brady nodded very seriously. It would be enough.

But what of the money? His wife and friends, seeing Brady was in earnest, pointed out the potential cost of the undertaking. Brady dismissed their objections. On Gardner's advice, he had made a deal with Anthony & Co. Anthony would make hundreds of small prints from Brady's studio's negatives. Brady was assured of profits from the sale of the prints by Anthony. The sum owed Brady would be at least $4,000 a year, according to Gardner's calculations. He would be relieved of the nuisance of making endless cartes de visite. And his gallery had already made him a rich man. He had a fortune of $100,000, the lots in Central Park, the galleries, the stock in oil wells and silver mines. Money? Think of the demand there would be for pictures of the war! That only Brady would be able to provide.

So the decision was made. It was fateful for Brady's career and for his place in American history. It changed his life for good. Yet it was entirely consistent with the vision that unified his career— to seek out and record history. Without the Civil War pictures Brady would still have a place in the history of American photography, but the war pictures—even though hundreds of photographers took part in the effort—gave "Photo by Brady" a special meaning.

When Brady plunged into the war, he could not know that he would be destroying his career even as he achieved greatness. Perhaps in the end he had some qualms. But as he recalled at the end of his life, "Destiny overruled me . . . I felt I had to go, a spirit in my feet said, 'go,' and I went!"

"I HAD MEN IN ALL PARTS OF THE ARMY"

THE Confederacy awaited the North's response to Fort Sumter and the seizure of Federal property throughout the South. The North, militarily, had the advantages of greater industrial power and a larger population. But the South had the great advantage of defense. The North, to win, had to march in and physically conquer the South. The South had only to hold its own territory. And most of the skilled generals of the country were Southerners trained at West Point. The North had to scrape the bottom of the barrel for officers.

General McDowell, now commanding the Union forces, wanted time to properly train the ragtag bands of volunteers that were camped in and around Washington. But the North wanted a quick victory. In the New York *Tribune* Horace Greeley was sounding the cry, "Forward to Richmond!" A quick victory against the Confederate forces in western Virginia by Union troops under General George B. McClellan brought forth more pressure for McDowell to move.

The main Confederate Army was only twenty-five miles from

Washington, at Manassas Junction, its only natural defense a sleepy little river called Bull Run. On July 16, 1860, McDowell and a force of 35,000 men set out from Washington toward this rendezvous.

Half of Washington, it seemed, was following behind them. The atmosphere was that of a pleasant summer picnic. The expectation was that the Confederates would be routed at once, and everyone in Washington thought it a lark to follow along to watch.

McDowell's army was colorful to see. A wide variety of uniforms reflected the traditions and sympathies of the communities that had sent volunteers. A New York regiment called the Highlanders had Scottish plaids and kilts for dress parades. Other regiments adopted the dress of the French Zouaves—baggy red breeches, short blue coats, yellow or scarlet sashes about the waist, and even turbans or fezzes as headgear.

The undisciplined, poorly trained Union soldiers broke ranks as the spirit moved them, wandering off to pick blackberries or take a cooling draught from a shady well. The officers were tolerant; the weather was hot, and the road dusty.

Somewhere in the meandering train rode Brady, as confident of victory as the rest. He had outfitted himself with a splendid wagon with a light-tight covering to provide a portable darkroom. Inside were all the glass plates, bottles of chemicals, cameras, developing tanks, and equipment he would need—just as in the studio—along with a helper or two. Brady wore a clean linen duster to protect his tailored clothes and a broad-brimmed hat that would become his trademark throughout the war. One observer thought he looked like a Paris art student.

It took McDowell's army two days to cover the twenty-five miles to Bull Run. By that time the Confederates were well aware of the approaching army. They could have read of the troop movement in the

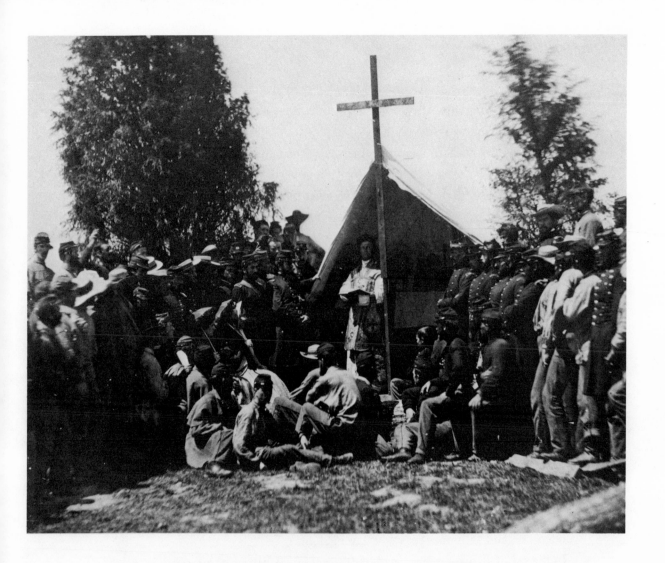

Brady's photograph of Father Thomas H. Mooney saying Mass before Bull Run for the soldiers of the 69th New York Militia, many of whom were Irish Catholics. Father Mooney was later recalled by Archbishop John Hughes of New York. Father Mooney's enthusiasm for the Union cause had led him to some questionable religious practices. He baptized an artillery gun at Fort Corcoran, giving it the name Hunter Gun.

Northern newspapers. A few more days of maneuvering to get the Northern troops into an orderly battle position gave the Confederates more time to bring in reserves.

Brady was everywhere snapping pictures. Most were of willingly posed soldiers who were eager to record their heroic presence, even though not much in the way of a battle seemed likely. More Washington sightseers arrived as the tales of the relative safety of the battlefield drifted back to the city.

Finally, on the twenty-first, the armies engaged one another. In the confusion of a real battle green troops on both sides thrust aimlessly about, searching for what might be the enemy. A Confederate counterattack was not fired upon by Union troops because this particular group of Rebels was wearing blue shirts.

The Union line broke. Without proper training in tactics of withdrawal, the retreating soldiers resembled a mob. The carriages of Washington civilians rushed onto the road for home, clogging the withdrawal route. The panicked soldiers took to the woods.

Brady held his ground, taking pictures of the frenzied crowd. The Confederates rushed ahead. There was a loud crash, and Brady looked to find his wagon overturned, its contents smashed. He salvaged a few exposed plates that had been protected by their heavy wooden box and set out across country on foot.

In the chaos firing stopped, both sides fearful of hitting their own men. Brady wandered in the woods for three days, carrying his plates and searching for food with the other stragglers. He ran into a company of Zouaves made up of volunteers from a New York Fire Department. One of them gave him a sword to protect himself. When he finally made his way to Washington, he carried the sword and the collodion plates as his trophies of battle. He hadn't lost his swagger, however, and posed before the camera in his begrimed "battle dress."

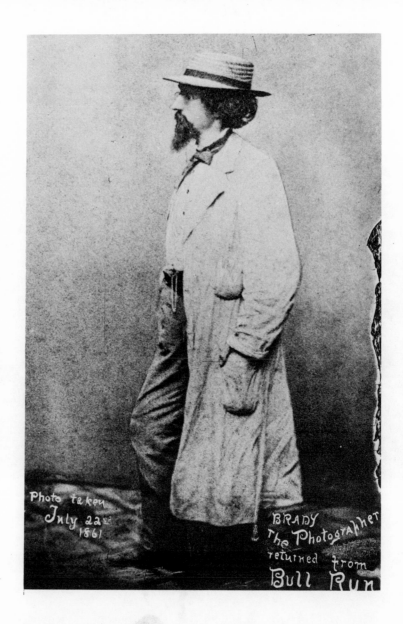

Photo taken
July 22d
1861

BRADY
The Photographer
returned from
Bull Run

Brady after the Battle of Bull Run. He is still in his field costume, and the scabbard of the sword given him by the company of Zouaves can be seen protruding from the bottom of his linen duster. He appears unfazed and a little proud of his ordeal.

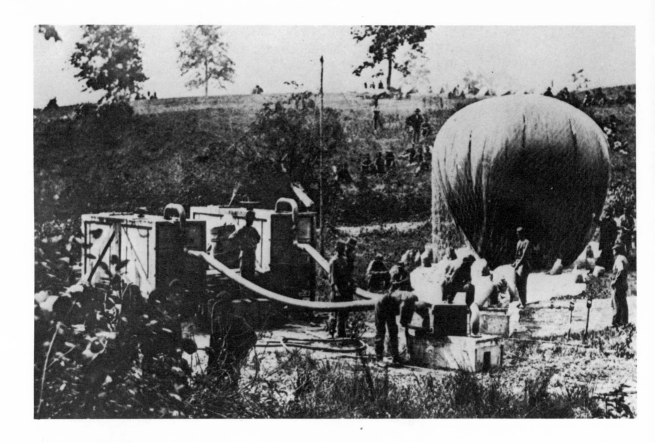

One of Professor Thaddeus Lowe's experiments with balloons, as photographed by Brady's staff. The balloons showed promise of being useful in observing enemy troop movements. But men on the ground had to control the balloon with ropes, since otherwise it could be carried away by the wind. In addition, it was a large, tempting target for enemy sharpshooters.

The North was stunned by the defeat and searched the scenes on Brady's plates for an explanation. The newspapers analyzed them in detail. "He has fixed the cowards beyond the possibility of a doubt," wrote one journalist.

Meanwhile, General McClellan replaced McDowell as head of the army. McClellan sent the volunteers home and began making preparations for a real army of 500,000 men on three-year enlistment. The Union now realized that the war was serious, would be long and bloody, and would require a sustained effort to win.

Brady, too, was assembling his "troops" for the war. Brady himself would travel only to the battlefields close to Washington. He was also to record all the major generals and political figures of the Union side. He never visited the western front, although he obtained photographs from there taken by his own men and other photographers working on their own. Eventually, Brady would have as many as twenty teams of men assigned to various parts of the war. He would recall, "I had men in all parts of the army, like a rich newspaper."

The names of many of the Civil War photographers have been forgotten. Some of those who worked for Brady were Alexander Gardner, T. H. O'Sullivan, Guy Fox, James Gardner, T. C. Roche, John Reekie, William R. Pywell, David Knox, Louis Landy, and Andrew Burgess. George S. Cook, who had managed Brady's New York gallery when Brady was in England, returned home to the South. He followed the Confederate armies, making a record of the war from that viewpoint.

Despite the lull in the fighting while McClellan organized and trained a new army, there were many war-related activities for Brady's men to photograph around Washington. A Professor Thaddeus S. C. Lowe set up gas generators on the Mall near the Smithsonian Institution to inflate aerial balloons. Lowe hoped to convince

Congress of the feasibility of using the balloons for war reconnaissance. Brady's cameras were there to record the scene.

Over on the White House lawn a herd of cattle stood grazing. The Quartermaster Corps had procured them for feeding the troops and had to pasture them somewhere until they could be slaughtered. Someone from Brady's was sent to capture the moment.

Brady took several more photographs of Lincoln during the war, at the Washington studio and at the White House. In 1863 two soldiers entering Brady's studio were given the usual numbered cards to wait their turn to be photographed. As they waited, they were amazed to see Lincoln enter the gallery. They gave up their places in line to let Lincoln be photographed and were invited into the camera room with him. One of the soldiers recorded the scene in his diary:

> The operator was a Frenchman with a decided accent. He said to the President that there was a considerable call for full-length standing photographs of him. The President, joking, inquired whether this could be done with a single-sized negative. "You see, I am 6'4" in my stockings," he said. . . .
>
> "Just look natural," said the operator.
>
> "That is just what I would like to avoid," Mr. Lincoln replied. . . .
>
> "That camera man," continued the President, "seemed anxious about the picture, but boys, I don't know what might happen to the camera."

Andrew Burgess, another of Brady's operators, took the famous picture of Lincoln reading to his son Tad on February 9, 1864. Actually the book Lincoln is holding is a photo album from the studio. Lincoln disliked this prop, feeling that the solemn look of the book's cover might mislead people into thinking he was "make believe reading the Bible to Tad."

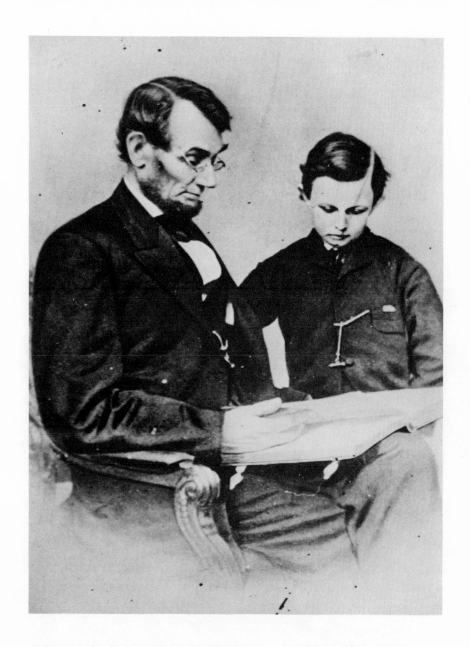

Andrew Burgess, an employee of Brady's Washington gallery, took this photograph of Lincoln and his 8-year-old son Tad in 1864. The youngest of Lincoln's four sons, Tad was a terror to the White House staff, but Lincoln was usually indulgent to him.

At the beginning of the war, business was booming at Brady's, but there was disharmony between Gardner and Brady. Gardner had been used to running his own show in Washington while Brady remained in New York. Now that Brady was spending most of his time in Washington close to the war, Gardner's authority was weakened. Another sore spot was the fact that all the gallery's photos were stamped "Photo by Brady," no matter who took them. Gardner —and, it turned out, others in Brady's employ—resented the lack of credit he got for his own fine work.

Gardner found an opening on McClellan's staff for an official photographer with the honorary rank of captain. He left Brady's gallery to travel with the army. In 1862, when McClellan was temporarily replaced, Gardner left the army and in partnership with his son and brother set up his own gallery. Timothy H. O'Sullivan and Guy Fox, two of the best of Brady's photographers, joined him.

Despite the split there seemed to be little real enmity between Gardner and Brady. Brady's major purpose at this time was collecting as many pictures of the war as he could gather. If Gardner wanted to set up his own gallery, fine. Brady would deal with Gardner just as he dealt with official army photographers and other independent cameramen. Brady made copies of others' prints and negatives for his collection. He obtained duplicate or second-best photos from any photographer who would let him have them. His idea was to form a collection that would be as complete as possible, including scenes of the war along with individual pictures of officers and men, from drummer boys to generals.

During the war Brady put together two albums of the choicest war views he had available. The *Album Gallery* and *Incidents of the War* with paper positives pasted to the pages sold for a hefty seventy-five dollars each and were not popular.

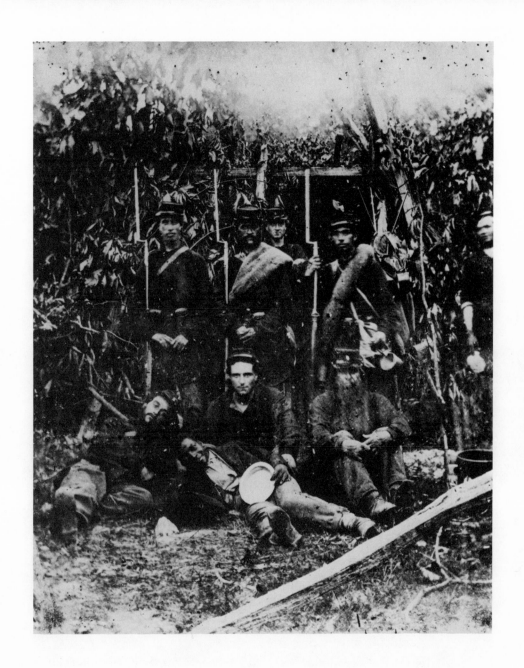

Infantry soldiers posing for one of Brady's cameras.

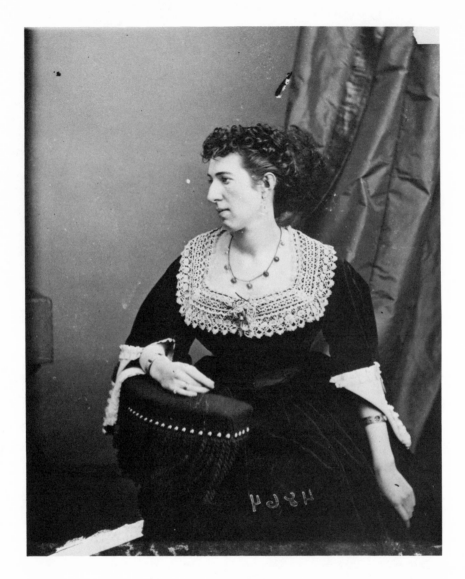

Belle Boyd, Confederate spy, who was only 19. She was imprisoned
by the North for passing on to the Confederacy valuable information
that she obtained from gullible Union officers.

But in 1861, Brady's gallery was turning a profit of $12,000 a year in Washington alone. The materials and equipment to photograph the war were being provided by Anthony & Co. Brady's credit was good with Anthony, for there was the prospect of more profits after the war. Anthony saw a rich market for the stereo cards of Brady's war views.

Then the loss of Gardner began to tell. Brady had placed James F. Gibson in charge of the Washington gallery. Gibson was a good photographer, but sadly lacking in business ability. The profits from the Washington gallery eventually dropped to $480 a year. Proceeds from the licensing of photographs to Anthony dropped from $4,000 annually to $276.

But Brady wasn't concerned with that yet. In the spring of 1862 McClellan finally responded to the advice of the editors and politicians, and the Army of the Potomac began to advance again. Brady, Gardner, and the other photographers followed. There was a war to photograph!

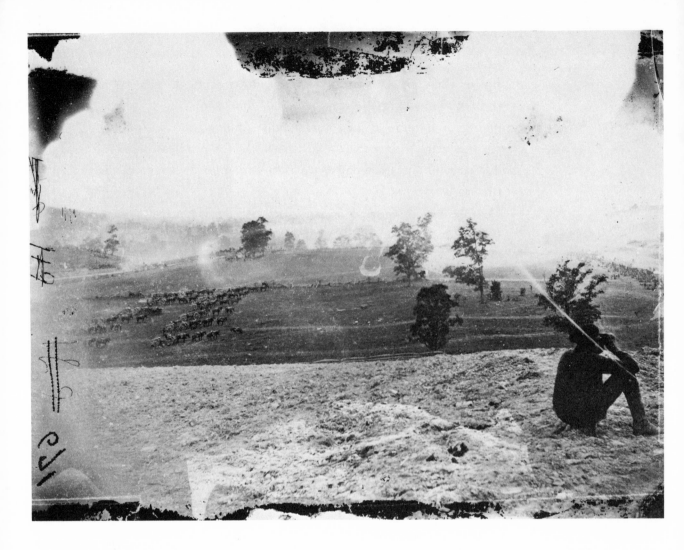

The Battle of Antietam, as seen by Brady's camera from a hill. The smoke indicates the battle is actually taking place, making this one of the very few "action" photographs of the war. Lee's forces, advancing from the left, were thrown back by McClellan's army in a bloody battle.

THE BATTLEFIELD

THE job of photographing the war was almost unbelievably difficult by modern standards of photography. The operator of the camera—or, if he was lucky, his assistant—had to make his own photographic plates on the spot so they would still be sticky when inserted in the camera. They had to be developed within minutes after exposure. This meant that a darkroom, usually a tent or wagon covered with black cloth, had to be nearby, complete with plates, chemicals and developing equipment.

The discomfort and danger of working in a stuffy, pitch-dark wagon while bullets and shells were being fired only a few hundred yards away were only the first of the photographer's worries. The plates had to be protected against breakage, fingerprints, drops of sweat, and stray insects that might land on the sticky collodion. Even a sudden change in humidity could ruin a fresh plate.

As it happened, too, the ingredients of the collodion coating were all potentially injurious to the operator. He might burn his skin, irritate his eyes, or be overcome by the noxious fumes from the plates he was trying to prepare.

To start the process, a photographer would remove one of the 8 x 10 inch (the usual size) glass plates from its box and balance it from underneath on the tips of his fingers. Then he would pour the thick collodion fluid onto the plate. Tilting the plate back and forth, he gradually coated the surface with the mixture. After allowing the collodion to dry to just the right degree of stickiness, the photographer lowered the plate into a deep "bath holder" containing silver nitrate which had to be kept near sixty degrees for the operation to work. The plate was left in this bath for three to five minutes and then placed in a light-tight holder. It then had to be used within a few minutes. In very cold weather, the sensitivity of plates was extended, but never lasted for more than an hour.

After the exposure the plate had to be developed with more dangerous chemicals, washed in the nearest stream, and then protected against all the dangers of the battlefield and the long trip back to the gallery. Remarkably, many photographers were successful in producing thousands of photographs under these conditions.

There are practically no examples of what we would call action shots of the Civil War. Exposure times were still too long, and the difficulty of the collodion process too great, to permit the taking of photographs during a battle. On one occasion when O'Sullivan lined up Union artillery crews in battle position to simulate real firing, the Confederates became alarmed and sent a few shells in their direction. Even so, Brady and the other photographers often braved the dangers of the war and suffered many close scrapes.

The black-covered photographic wagons traveling in the wake of the army reminded the soldiers of hearses, not a comforting association. But gradually the photographers won acceptance, perhaps because they captured the soldiers in mock-heroic poses before the battles took place. Once the photographic wagons became familiar

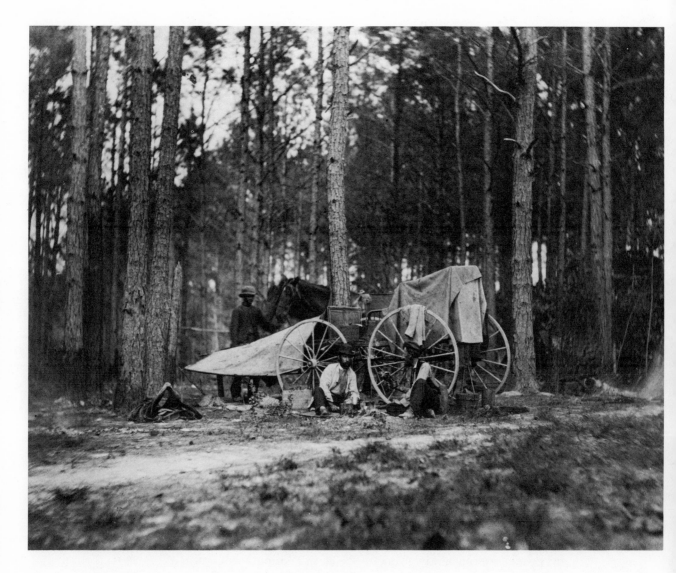

One of Brady's What's-It wagons during the siege of Petersburg.

sights, they were hardly noticed on the battlefields. The soldiers called any darkroom wagon "Brady's what's-it wagon," because the first time they saw it, they said, "What's it?"

During 1862 the Union army on the Virginia front had suffered from a series of blunders. In September General Lee, commanding the South's Army of Northern Virginia, launched a threat against the North, invading western Maryland. McClellan, having been relieved and now restored to his command, moved to check Lee.

The two armies met on September 17, 1862, at Antietam Creek. Brady and Gardner were two of the photographers present. It was one of the bloodiest days of the war; over 12,000 Federals and more than 10,000 Confederates died. The Confederates began a slow retreat. Brady and Gardner followed the carnage across the battlefield. There were no mock-heroic pictures of posing soldiers now. The only men who remained still long enough to be photographed were dead.

A writer for the New York *Times* recorded his thoughts on seeing Brady's pictures of Antietam displayed at the Tenth Street gallery in New York:

> Mr. Brady has done something to bring home to us the terrible reality and earnestness of war. If he has not brought bodies and laid them in our dooryards and along the streets, he has done something very like it. At the door of his gallery there hangs a little placard, "The Dead of Antietam." Crowds of people are constantly going up the stairs; follow them, and you find them bending over photographic views of that fearful battlefield. . . . There is a terrible fascination about it that draws one near these pictures and makes him loth to leave them. You will see hushed, reverent groups standing around these weird copies of carnage, bending down to look

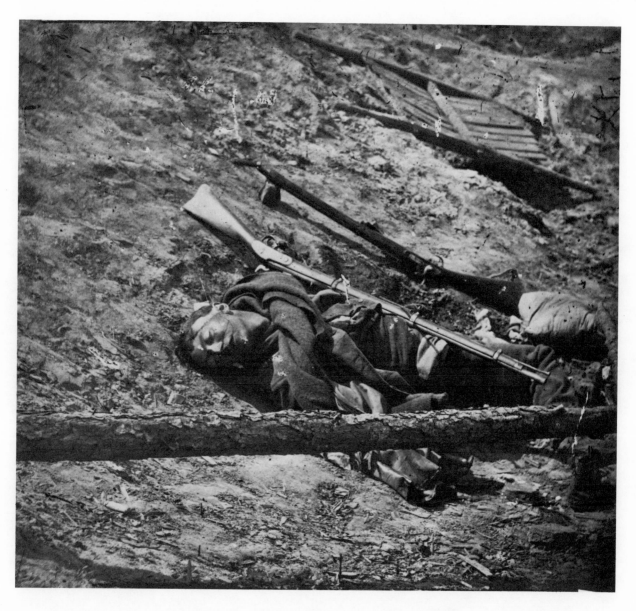

One of the men who lost their lives at Fredericksburg.

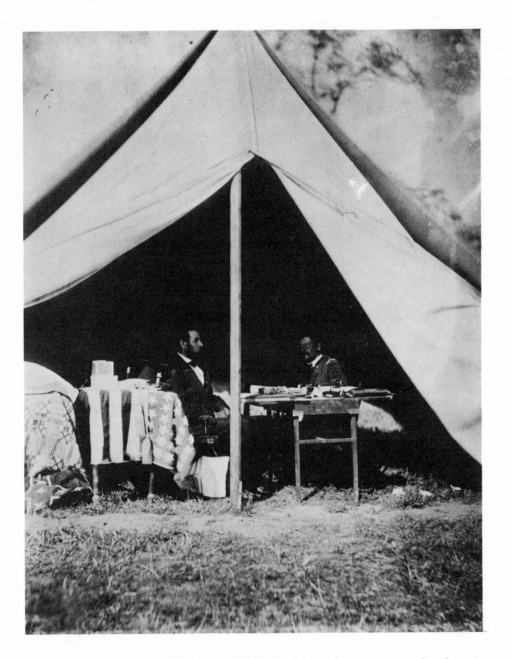

Lincoln and McClellan at McClellan's headquarters on October 4, 1862. Lincoln replaced McClellan a month later.

in the pale faces of the dead, chained by the strange spell that dwells in dead men's eyes. . . . These pictures have a terrible distinctness. By the aid of the magnifying glass, the very faces of the slain may be distinguished. We would scarce choose to be in the gallery when one of the women bending over them should recognize a husband, a son, or a brother in the still, lifeless lines of bodies that lie ready for the gaping trenches.

In October, 1862, Lincoln visited McClellan's headquarters. Gardner took pictures of the two men together. A month later Lincoln replaced McClellan with General Ambrose Burnside. By the middle of November Burnside was moving the Army of the Potomac south into Virginia. Brady knew Burnside well and was on hand himself when the Union disaster crossing the Rappahannock River at Fredericksburg took place.

Burnside had dallied on his side of the river for two weeks while he cautiously brought up more men and pontoon bridges. This delay gave the Confederates time to prepare a massive defense position across the river on Marye's Heights, overlooking Fredericksburg.

On the bitterly cold morning of the eleventh of December there was a dense fog which gave the Federals cover for laying their pontoon bridges across the river. Brady set up his camera on the bank of the river, waiting for the fog to clear. Suddenly Confederate sharpshooters across the river sighted the brass lens barrel of Brady's camera glinting in the fog. They opened fire. The horses pulling the what's-it wagon bolted and ran. Brady himself scurried for cover. Assistants went after the wagon, finding much of its contents smashed. Unhurt, Brady set out to repair the damage. Fortunately none of the gunfire had hit the camera.

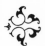

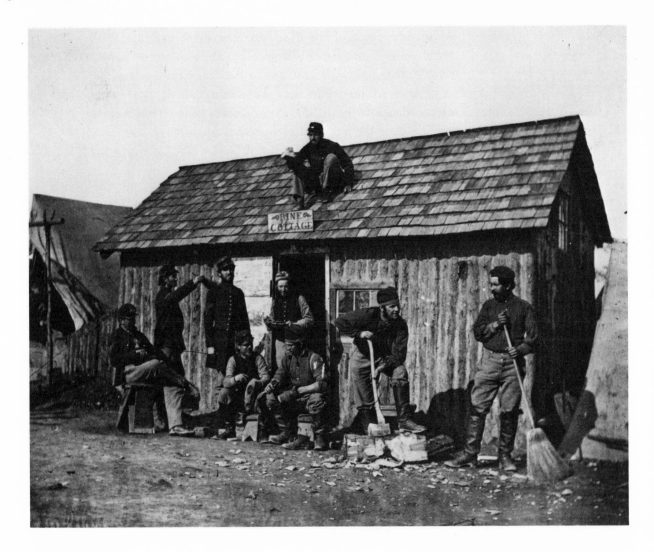

This group of Union soldiers is shown outside of their winter quarters, where they mended their equipment, wrote letters home, and sent pictures like this home to loved ones.

On the following day Union forces succeeded in crossing the river and captured Fredericksburg. The Southerners still held the Heights beyond. The next day, Burnside's men stormed the defense positions and ran smack into reserve forces commanded by "Stonewall" Jackson and General James Longstreet. Two weeks before, when Burnside had first advanced to the river, these Confederates had been miles away.

Burnside's men made six attacks on the Heights on December 13, with a loss of over 12,000 men. The Confederates lost a little over 5,000. On the fifteenth a truce was declared to allow both sides to collect the wounded and dead. Now the what's-it wagon looked truly a hearse as it slowly moved among the frozen bodies, stopping to allow Brady and his men to photograph the carnage.

Burnside finally withdrew across the river, abandoning the town, and the army settled into winter quarters. The following year Burnside was replaced as commander of the Army of the Potomac by "Fighting Joe" Hooker. Hooker got off to a bad start, losing 17,000 men at the Battle of Chancellorsville. This victory for the South gave new hope to Lee; he would make a second attempt to invade the North in the summer of 1863. Lee consolidated his forces in June and began to move around Hooker's army. Unfortunately for Lee, the parts of his army became separated in the process and were less able to defend themselves against the North's superior numbers.

General George Gordon Meade now replaced Hooker in command of the army. Meade advanced on Lee's forces, and they engaged in a terrible battle around the town of Gettysburg, Pennsylvania, on July 1–3, 1863. Brady, O'Sullivan, and Gardner were there, moving in and out of cannon range, recording the ghastly "harvest" in the farmland of Pennsylvania.

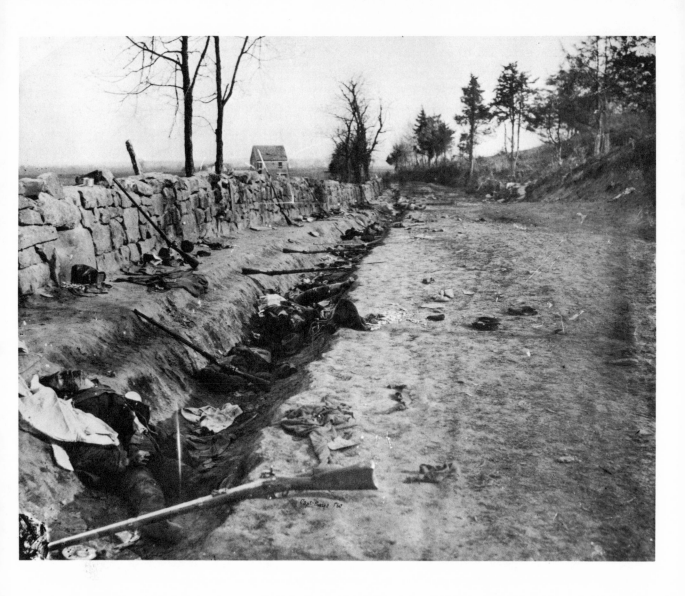

The stone wall on Marye's Heights, at Fredericksburg, that Burnside's men failed to carry in December, 1862. From this position, 9,000 men were able to withstand the attacking force of 20,000 men under Burnside. A Union army took the Heights in 1863, when Lee withdrew forces that were needed elsewhere.

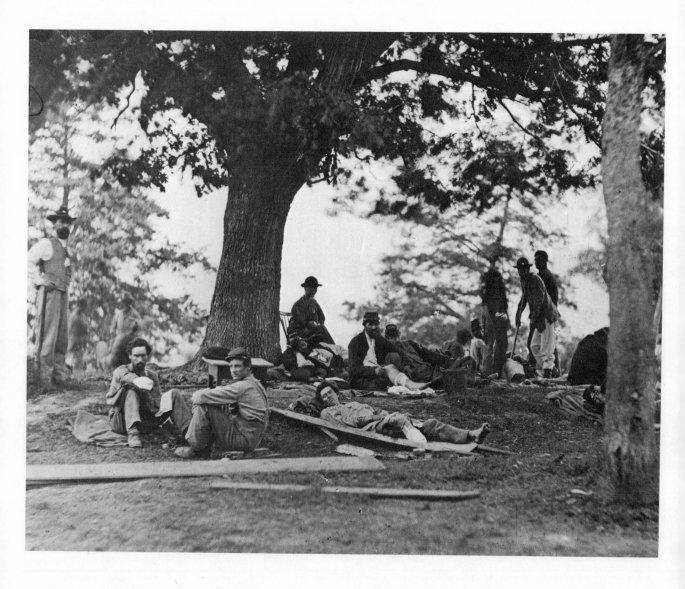

After the Second Battle of Fredericksburg, wounded Union Soldiers
survey the ground they have won. There are no cheerful smiles for
the cameraman now.

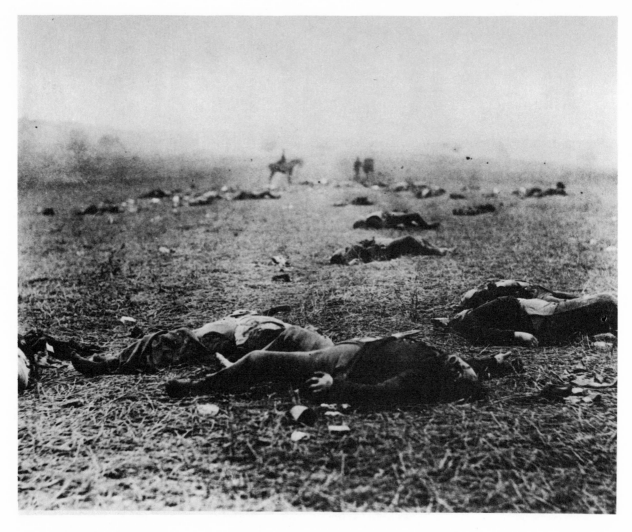

Timothy O'Sullivan's famous photograph of the battlefield of Gettysburg in July, 1863, titled "The Harvest of Death." The dead men have no shoes because they were desperately needed by those who survived. Gardner's description of the photograph mentions ". . . the litter of the battlefield, ammunition, rags, cups and canteens, crackers, haversacks, and letters that may tell the name of the owner, although the majority will surely be buried unknown by strangers, and in a strange land."

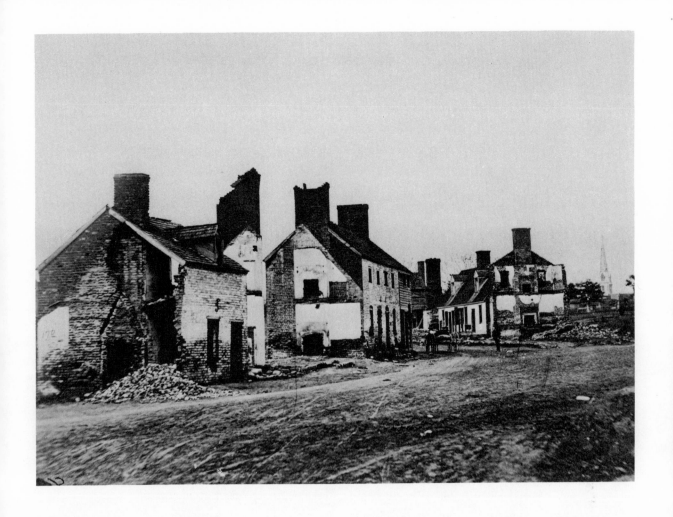

The town of Fredericksburg in ruins, 1862, after the first battle of
Fredericksburg.

The Northern forces had the worst of the battle for two days, but Lee could not quite muster the forces to send Meade's army to rout. On the third day Confederate General George Pickett led a gallant charge with 15,000 men in a line a mile long, the rebel yell in their throats, storming toward the main Federal position on Cemetery Ridge. The Federal cannon and musketry rained fire on Pickett's men, tearing the Confederate line asunder. Pickett's charge failed, the last great Southern advance against the North was beaten back, and the Battle of Gettysburg was over. Lee, having lost a third of his army, retreated into Virginia. The South would now be forced into a defensive war. The North lacked only a general who could effectively use his superior forces to crush Lee's army once and for all.

Lincoln looked to the western theater of the war, where the news for the North had been good. Early in 1864 the rumor swept Washington: Grant was being placed in charge of the army. Everyone knew of Ulysses S. Grant, the officer who had come back from disgrace, resignation from the army, and seven years as a shopkeeper. All one heard about in Washington those days were the victories General Grant's army had won along the Mississippi River. But no one knew what Grant looked like. "Check with Brady. He'll have a picture," people said. *Harper's* and *Leslie's* sent urgent telegrams to Brady: "NEED PHOTO GENERAL GRANT."

On March 8 the afternoon train pulled into Washington at the Baltimore and Ohio railroad station. A quiet little man in a goatee and mustache, smartly dressed in a black suit, was waiting to meet it. No one else was around as a soldier in a rumpled uniform with an unbuttoned tunic and a cigar jutting out from a bristling beard stepped off the train. Grant's arrival was supposed to be a secret, and it was—to all but Brady. Brady courteously introduced himself and

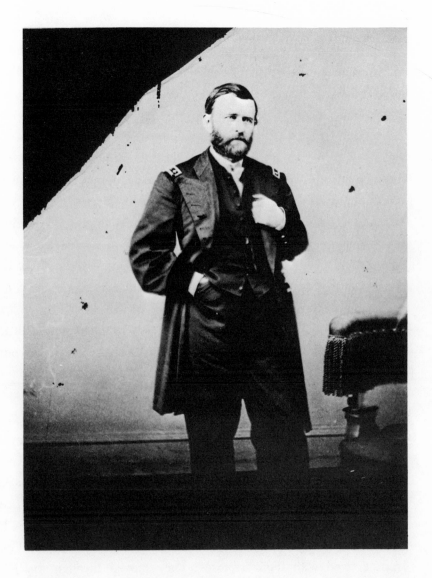

One of the photographs of Grant taken in Brady's studio on March 9, 1864, after the studio assistant stepped through a skylight and sent glass showering down on Grant.

offered his help. Grant asked where a man might find a good hotel in this town. Brady recommended Willard's. As he helped Grant lift his luggage into a waiting carriage, Brady wondered aloud if he might trouble the general to come by the gallery for a sitting.

Sometime the next day, when Grant's appointment was officially announced, Grant walked into the gallery of his new friend, Brady. Secretary of War Stanton accompanied him. Brady was ready with three cameras in the operating room to take as many pictures as time would allow. As the photographers were about to start, the sun went behind a cloud. Instead of waiting a few minutes for the sky to clear, Brady impatiently sent an assistant to the roof to remove the shades that were in place. The hurrying assistant accidentally put his foot through one of the skylights, showering Grant with shards of glass.

The studio hushed for a frightened second, but Grant calmly brushed away the glass and returned his gaze to the cameras. Brady breathed a sigh of relief and waved the operators to hurry. *Harper's* and *Leslie's* were waiting.

After a spring of preparation Grant set out on his task with grim determination. Beginning on May 4, 1864, Grant set his army in motion and dogged Lee's steps through Virginia to the James River. Lee again set up a defensive position on the opposite bank, as the Confederates had at Fredericksburg. But Grant sidestepped Lee's defenses and crossed the James River upstream, unopposed. Now his men laid siege to the railroad center of Petersburg. Brady and O'Sullivan arrived with their cameras. They moved through the lines around the city, taking pictures of the mammoth Union guns and their crews. Answering shells from the town once again fell near Brady, spooking his horses and again destroying many of his fragile supplies.

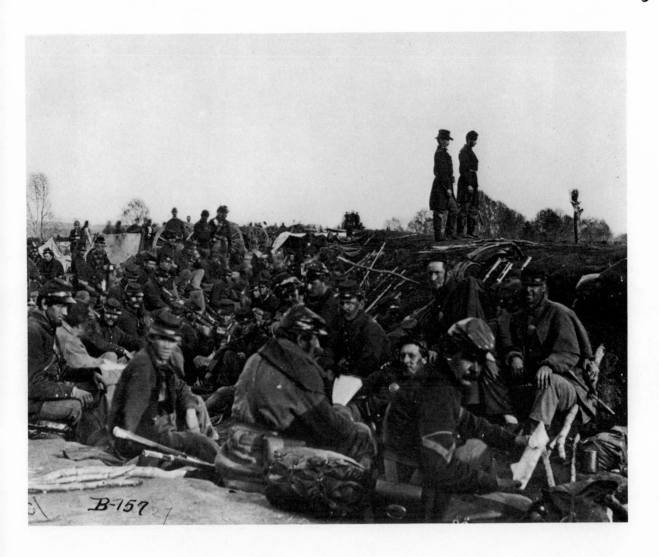

The Union troops in their trenches near Petersburg, Virginia, in 1865. Grant avoided the mistakes of his predecessors and did not try to attack the city. Instead, he fought his way around it and cut off the supplies of the Confederate defenders.

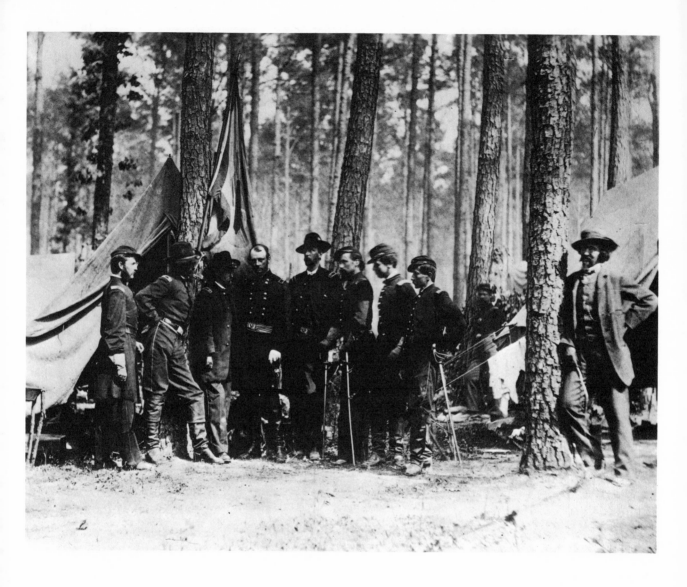

A photograph of Major-General Robert B. Potter and his staff just before the Battle of the Wilderness in May, 1864. The civilian casually leaning against the tree on the right is Brady.

Grant lost 60,000 men in the first month of the campaign, but he was moving forward. The North had replacements for Grant's dead; Lee had no reserves to draw on. Grant's strategy was faultless, but the casualty lists continued to mount. He drank to forget the casualty lists and moved onward toward Richmond.

Finally the bloodshed ended. Lee, seeing the inevitable, offered his sword to Grant in Appomattox Court House. Grant accepted the surrender and sent Lee home with his sword.

Brady arrived at Appomattox too late to record the scene. It was small comfort that no one else had gotten it either. Brady set out for Richmond. He had pictures of all the Northern generals, and now he wanted Lee's. Brady was collecting history now, and he was finding that even though the war had stopped, history continued forever.

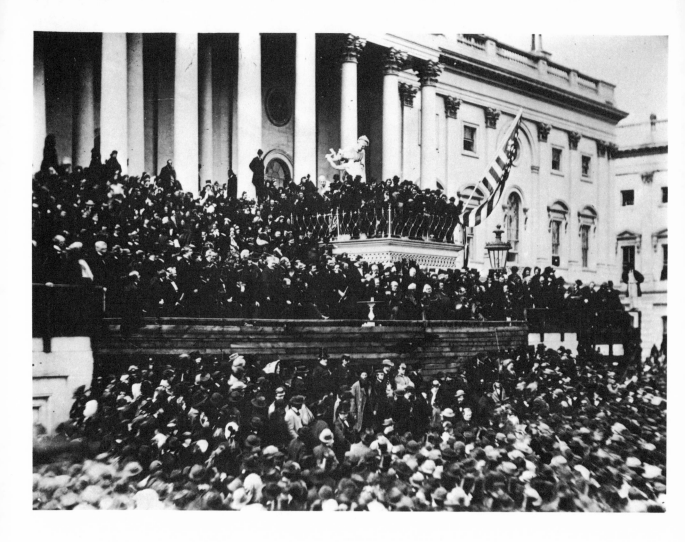

Lincoln's second inauguration, March, 1865, in which he proclaimed his intentions toward the defeated South "... malice toward none, with charity for all." Unfortunately, after Lincoln's death, the Republicans in Congress adopted a policy of harshness toward the South, leaving scars of bitterness that would remain for a century.

"MALICE TOWARD NONE"

AS Brady with his what's-it wagon trundled slowly through the ruined streets of Richmond, he learned of the assassination of Lincoln on April 14, 1865. He may have thought of the words of Lincoln's Second Inaugural Address, spoken only a month before, on March 4. Brady's cameras had recorded the scene, and Brady heard Lincoln speak the conciliatory words to the soon-to-be-defeated South: "With malice toward none; with charity for all; with firmness in the right; as God gives us to see the right, let us strive on to finish the work we are in; to bind up the nation's wounds; . . . to do all which may achieve and cherish a just, and a lasting peace. . . ." Grant had carried out Lincoln's wishes in offering Lee generous surrender terms, just as General Sherman was offering generous terms further south to the defeated Confederate Armies there.

Brady stopped to photograph rubble in the streets of Richmond. Confederate troops had burned the city when they abandoned it. Some newly freed slaves posed for his camera. Finding a place for these new citizens in the life of the country would be one of the tasks of the new President, Andrew Johnson.

At last Brady found the Lee residence. Brady had known Lee

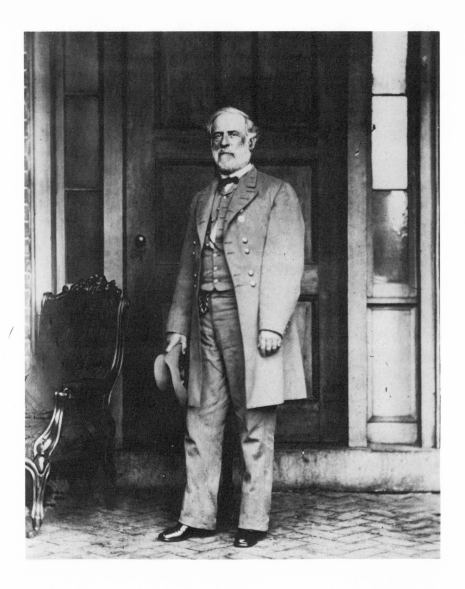

Robert E. Lee as Brady photographed him outside the Lee house in
Richmond. Usually facing superior numbers, Lee used the strategy
of evasion so well that the North had few generals who could defeat
him.

years before when Lee was a young officer on the staff of General Winfield Scott during the Mexican War. Even so, it would seem the wrong time to approach him to ask to take a picture from which he would always be remembered—as the leader of the defeated Southern armies. But Brady secured the assistance of Mrs. Lee and Lee's fellow general, Robert Ould, in persuading Lee to pose.

Brady was shocked when he saw Lee. He remembered Lee as a vital young man with a thick head of jet-black hair. The photos of Lee which were current during the war showed him the same way. However, the Lee that stepped onto his back porch to pose for Brady had a full head and beard of totally white hair. The war had taken its toll, but the pictures Brady took showed in the sternness and clarity of Lee's gaze that the man had kept his pride.

Lee had opposed both secession and the war. Lincoln had even offered him command of the Northern armies. But Lee had carried out his duty to his native Virginia and had gone back to lead the men in gray. His eyes showed that no man could accuse him of dishonor. Brady's photos, seen in the North, helped quiet the demands that Confederate leaders be hanged for treason.

When he returned to Washington, Brady was among the first to obtain a photograph of President Andrew Johnson. Congress had recently made it possible for photographers to copyright their work. Brady took out a copyright on the Johnson photo. When another photographer made and sold copies of Brady's photo, Brady sued and won.

There were other photos by Brady in 1865. General William T. Sherman, whose men had devastated the South in their march to the sea, appeared with his staff for a group photograph. The Grand Military Review, in May, 1865, presented the victorious armies in review. Brady captured them with his camera. One of the younger Union commanders, General George Custer, appeared in Brady's studio to have his portrait done.

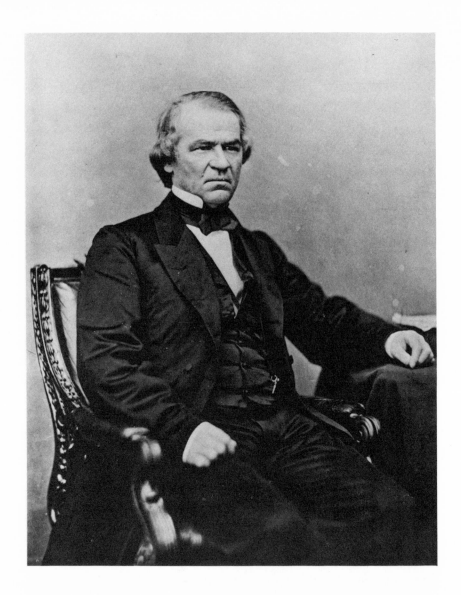

Andrew Johnson, seventeenth President of the U.S. The only president to be impeached by the House, he remained in office when the Senate failed by one vote to get the two-thirds majority necessary to expel him from office. Born in North Carolina, Johnson had been a senator from Tennessee, and his Southern origins alienated him from the "Radical Republicans."

General George A. Custer, the youngest Union general in the war.

But more and more Gardner was becoming the premier Washington photographer. It was Gardner who took pictures of the trial of Henri Wirz, the commander of the notorious Confederate military prison at Andersonville. Later Gardner photographed Wirz's hanging, at which the crowd chanted: "Wirz! Remember Andersonville!" And it was Gardner who photographed the multiple execution of the four who had been convicted of conspiracy in the assassination of Lincoln.

Where was Brady? He was in New York, trying to put his financial affairs in order. He had spent over $100,000 in the effort to photograph the war. His creditors wanted their money, and Brady didn't have the cash. The operations of the Washington gallery were becoming a drain on the more profitable New York studios.

Anthony & Co. discovered that what the public wanted most now was stereo cards. Millions were being sold yearly. Anthony offered to settle Brady's account for a complete set of the war photographs. Brady refused. There were thousands of prints and negatives in the collection. It was worth far more than what he owed Anthony. The public would be willing to pay to see it. The government would surely want it for its official records. It was priceless!

But the public, it seemed, was sick of the war. Brady had to reduce the price of his albums of war views from seventy-five dollars to fifty dollars. They weren't selling well. The public wanted to forget.

In 1864 Brady had sold a half-share in the Washington gallery to the manager, James F. Gibson, for $10,000. No doubt he thought Gibson would do a better job of managing if he had a stake in the business. Unfortunately, the finances of the Washington gallery only grew worse. Creditors began to sue, and in 1868 Brady finally declared the Washington gallery bankrupt. This was probably a legal tactic to get rid of Gibson, for the gallery was sold at public auction, and Brady repurchased it for $7,600.

In his defense Gibson blamed Brady for the gallery's failure. Brady insisted on preparing elaborate historical photographs that didn't bring in ready cash. In 1868 Andrew Johnson had been impeached by the House of Representatives and tried by the Senate. Despite the financial straits of the gallery, Brady ordered a composite photograph made of the entire Impeachment Commission. This work was time-consuming and expensive. When the Senate failed to convict Johnson by a single vote, Brady's expensive photograph stood as one more example of an episode the public wanted to forget.

In 1870 Brady reopened the Washington gallery on a reduced scale. He put Andrew Burgess in charge, and the business prospered once more. Perhaps prosperity was due in part to the fact that Alexander Gardner had closed his shop in 1867 to photograph the West for the Union Pacific Railroad. The talented T. H. O'Sullivan, responsible for many of the best Civil War photographs, also went west, where he carried on his brilliant work.

Sometime during the 1860s Levin Handy, the son of Julia Brady's brother, came to spend the day at his Uncle Mathew Brady's gallery in Washington. Family legend has it that Levin had been sent home from school that day for a classroom prank. The teacher is supposed to have said, "Go home till I send for you." She never sent for him, Levin Handy recalled, and soon he was a full-fledged operator in his uncle's gallery.

"A MAN'S DISTRESS"

BRADY had to raise money from his collection of war views. Debts were piling up; he still owed Anthony & Co. for the supplies they had provided on credit during the war. The most promising source of money seemed to be the government. Not only could the government afford to pay what Brady thought the collection was worth, but it could display the photographs in a national gallery where every American could come and look at them.

The government wasn't interested. Brady petitioned Congress regularly, beginning in 1867, to appropriate funds. In 1871 a committee recommended the purchase of two thousand portraits from Brady's collection for the Library of Congress. But no action was taken.

Brady collected letters, testimonials to the value of his collection. Grant wrote one, saying "how much more valuable it will be to the future generations." Admiral Farragut wrote of the pictures that he "admired their spirit and truth." The council of the National Academy of Design adopted a resolution urging that the Brady collection form the "nucleus of a National Historical Museum." Brady had a

scrapbook filled with newspaper clippings favorable to the government's purchase of his collection.

Brady released the news that the French government had made an offer for the pictures. The press raised a patriotic outcry and Brady gave assurances that he had declined the offer. The New York Historical Society made an attempt to purchase the collection, but the Society could not meet Brady's asking price of $100,000.

Meanwhile, the work of the galleries went on. Cabinet cards replaced cartes de visite in public popularity after the war. Cabinet cards were prints 4 x 5½ inches mounted on a card 4½ x 6½ inches. Because they were made from a larger negative than the cartes de visite and were often improved by a little artistic retouching, cabinet cards were more satisfactory for Brady's higher type of gallery. In addition they sold for considerably more than cartes de visite.

Brady's Washington gallery carried on the tradition of presidential portraits when Grant took the oath of office in 1869. Andrew Burgess, the Washington gallery manager, was also responsible for the photos of Mark Twain, Walt Whitman, and many other notables of Washington politics and society. General Robert E. Lee, now head of Washington University, visited President Grant in the White House and stopped by Brady's to have his picture taken again. Other Confederate generals, some now elected to Congress, visited the studio to add to Brady's still-growing collection of war views.

In New York Brady faced trouble. The gallery itself was still popular, but financially Brady was nearing disaster. The money spent on the war coverage had still not been repaid. Finally, Brady had to agree to settle his account with Anthony & Co. by allowing them to publish a set of the war views in their stereo card series. Brady was learning that even though he had spent a fortune collecting the war views, they were worth only what someone was willing

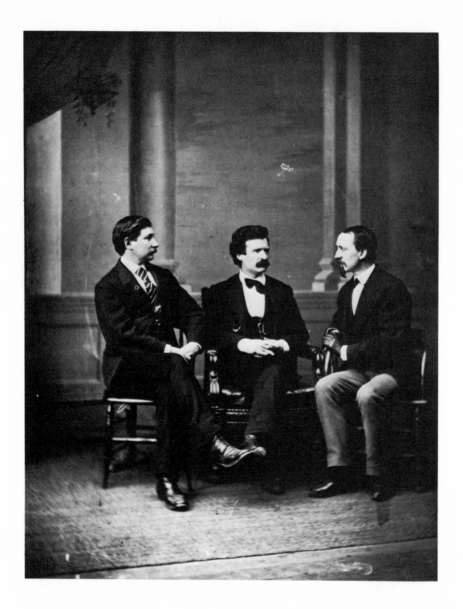

An 1871 Brady portrait of the journalist G. A. Townsend (left),
the author Mark Twain (center), and David Grady (right).

to pay for them. Only Anthony was willing to take them for cash.

The settlement with Anthony brought only a temporary respite. Bills for rent, supplies, clothing, repairs and hotel rooms were left unpaid. Brady had borrowed a good deal of money that he was unable to repay. In 1869 Brady sold his Central Park lots at Fifth Avenue and 105th Street to satisfy part of his debts. But a host of other creditors were still trying to get him into court.

Brady had avoided court judgments so far through use of political contacts, but the winds of reform were blowing through New York. The Tweed Ring was being exposed, and political honesty was suddenly in fashion. In January, 1873, Brady was unable to stave off bankruptcy any longer. The United States Marshal was ordered to seize Brady's galleries and to sell their contents.

Brady outmaneuvered the marshal by having the New York City Sheriff, a Tweed Ring crony, serve a second warrant authorizing the seizure of Brady's property. The sheriff made off with nineteen cartloads of Brady's equipment, supplies, and negatives before the marshal stopped him with yet another court order. Presumably, the nineteen cartloads of goods ended up in Brady's Washington gallery.

Brady now took up permanent residence in Washington, away from the unsympathetic New York courts. But the bankruptcy proceedings would deal him one more crushing blow. The glass negatives of the war views had been stored in a New York warehouse. The warehouseman who had possession of them won a court order allowing him to sell them for storage costs. When he put them up for auction, Secretary of War William Belknap purchased them for $2,840.

Brady was stunned when he heard the news. He went to the War Department and protested to Belknap that he had meant to redeem the negatives himself. Belknap was unmoved.

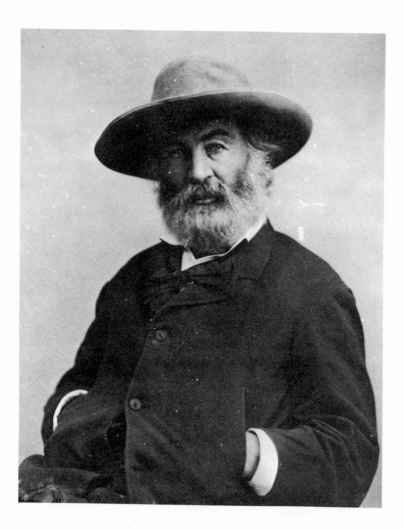

Walt Whitman, the famous American poet. During the Civil War, he worked in hospitals and wrote letters for the wounded. He supported himself by writing for newspapers. Brady probably knew him during that time, but this photo was taken in the postwar period. Whitman's book of poems, *Leaves of Grass*, had brought him fame but not much money until around 1880, when he was almost 60 and in poor health.

Brady turned to his friends in Congress. He mustered every legal and moral argument he could think of. The War Department didn't have clear title to the negatives. It was cruel for the government to rob a man of his life's work.

Some of Brady's friends came to his aid. Two former Union generals, now members of Congress, argued that Brady should be adequately paid for his work. General Ben Butler said the collection was worth $150,000 and the government should be certain of having clear title to it. General James A. Garfield, who would later be President, rose before the House of Representatives to plead Brady's case.

"Here is a man," Garfield said, "who has given twenty-five years of his life (and the life of any man, however humble his station may be, is worth something considerable) to one great purpose—to preserving national monuments so far as photographic art can do so, with a view of making such a collection as nowhere exists in the world. . . . Some of his men were starved, some wounded in the struggle. Then the government got three-quarters of his collection of these wonderful pictures in lieu of a storage bill. The government should not take advantage of a man's distress."

Finally, in April, 1875, the Congress appropriated $25,000 to Brady in return for clear title to the pictures. In desperation Brady accepted the offer. He had to meet his current expenses, or the Washington gallery would follow the New York studios into foreclosure. Brady began to rebuild the business in Washington with the help of his nephew, Levin Handy.

The cause of history was never sacrificed to mere profit in the Brady gallery, even in later years. Regularly, Levin Handy went out to photograph the stages in the construction of the Washington monument, which had been started in 1848, but was not completed until 1884.

Views of the various stages in the construction of the Washington Monument, taken by Brady's studio from 1848 to 1884.

Senators and Congressmen and judges and editors still came to Brady to have their pictures taken. The names of those his gallery photographed in the later years are as distinguished as those who came earlier: Salmon P. Chase, Chief Justice of the Supreme Court; Robert Todd Lincoln, Secretary of War in Garfield's and Arthur's cabinets; Susan B. Anthony, one of the leaders of the women's suffrage movement; Thomas Edison, the brilliant young inventor, who was taken with his phonograph; Walt Whitman, the famous poet; Charles Parnell, the Irish nationalist leader; Charles A. Dana, founder of the New York *Sun*; Alphonso Taft, Secretary of War and Attorney General under Grant and the father of President William Howard Taft—the list goes on and on.

The list of Brady-photographed presidents continued as well. In 1877 Rutherford B. Hayes was inaugurated as the nineteenth President, and became the thirteenth to be photographed by Brady's gallery.

The Hayes-Tilden election of 1876 was the closest in the nation's history. Certain electoral votes were in dispute that could throw the election to either man. Electoral commissions were set up to determine the validity of the various claims. Brady photographed the Florida Electoral Commission and offered the pictures to the public. The newspapers commented on Brady's pictures with delight. The *National Republican* said: "Of this important event . . . no better memory and knowledge can be had than in these photographs. Possessed of them, one can have a rogues' gallery that history will hold up to the contempt of humanity through all times."

First-hand accounts show that Brady, despite his advancing years and failing eyesight, still took an active role in the business. On one occasion Brady had made arrangements for the exclusive rights to take pictures of the delegates to an Inventors' Congress in Washington.

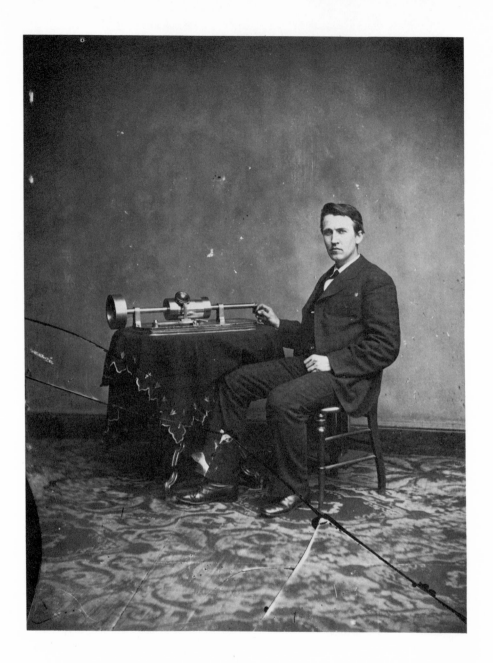

Levin Handy, Brady's nephew, took this photograph of Thomas A.
Edison at the White House, where he was demonstrating for President
Hayes his new invention, the phonograph.

Susan B. Anthony, as Brady's studio photographed her in the 1880's. She had been active in the anti-slavery movement before the Civil War. When the 14th and 15th Amendments granted civil and political rights to all male adults, she demanded the same rights for women as well. She published, lectured, and helped form groups to advance the cause of women's rights.

As Brady set up his camera in front of the Patent Office where the delegates were to pose, a competitor named George Prince arrived with his camera. Prince's burly assistant stood in front of Brady's camera, blocking the view. Brady responded by standing in front of Prince's camera. Prince tried to pull Brady out of the way, and a scuffle developed. A crowd gathered as the photographers, for once, became the spectacle instead of the spectators. The police were called.

Haled into court, the photographers told their story, and the evidence favored Brady. Prince was fined twenty-five dollars. Brady was vindicated, but the hurt to his dignity remained. The nation's premier photographer shouldn't be dragged into court for fighting in the streets.

In 1876 the nation celebrated its centennial of independence. A great International Centennial Exposition was held in Philadelphia. As with the Crystal Palace Exhibit, artists from all over the world sent their work to be displayed. The National Photographic Association raised $20,000 so that a building could be erected exclusively for the display of photographic work.

Brady saw the chance to regain whatever luster his name had lost by capturing the first prize at the exhibit. Squeezing dry the sources of funds he had left, he prepared examples of his best work—the work of a lifetime—for the competition. But this time the top honors were denied him. The judge awarded Brady a bronze Centennial Medal, more in recognition of his distinguished career than for the photographs themselves. He was honored as an elder statesman of the photographic world, when he wished to be thought of as still active and leading the way. But newer photographers, younger men, had passed him by.

THE FINAL YEARS

IN 1880 Brady's friend and benefactor James Garfield was elected to the presidency. Brady took Garfield's photograph in the winter of 1880, looking forward to Garfield's inauguration the following March. Perhaps now there would be lucrative government commissions for Brady. There was even a chance that Garfield would see to it that Brady got additional compensation for his war views.

But another tragedy in the country's history occurred. In July, 1881, a disappointed office-seeker shot Garfield. Garfield lingered in semiconsciousness all summer, throwing the nation into a constitutional crisis. It was agreed that Vice-President Chester A. Arthur should assume Garfield's duties, but whether as President or Acting President could not be decided. The business of the country ground to a halt until Garfield's death in September settled the issue.

In November, 1881, the Brady National Photographic Art Gallery at 627 Pennsylvania Avenue in Washington, D.C., closed its doors for the last time. The closing was due to a lawsuit filed by yet another creditor, but Brady was worn out from fighting. Earlier that

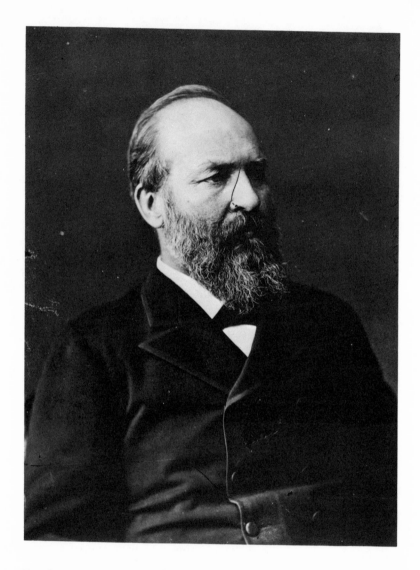

Brady's portrait of James A. Garfield, twentieth President. He received the nomination for president unexpectedly when the Republican convention of 1880 deadlocked between supporters of James G. Blaine and those who supported another term for Grant.

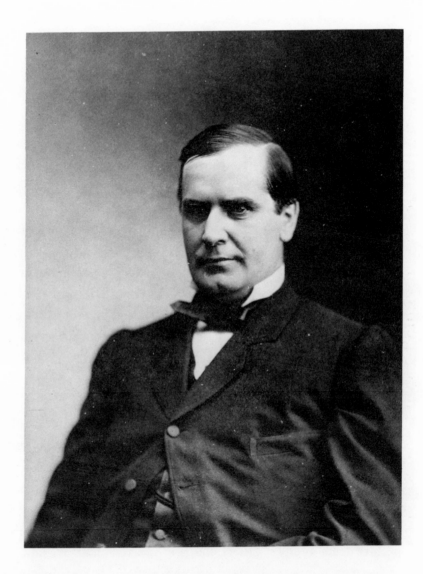

William McKinley, twenty-fifth President. Brady's studio photographed him when he was a Congressman from Ohio. Though he did not become president till after Brady's death, he completes the chain of presidents photographed by Brady.

year he had sold the three precious daguerreotype portraits of Webster, Clay, and Calhoun to the government for $4,000 but even that sum was soon swallowed up by angry creditors. The death of Garfield had been the final blow to Brady's hopes.

Levin Handy opened his own gallery with his Uncle Mathew Brady as an advisor. Brady showed up for ceremonial occasions, a symbolic figure used to give some class to Levin's business. Handy used his uncle's contacts in government to capture the same kind of official photographic commissions that Brady had. With Brady's help he kept up the family tradition of photographing Presidents, through Theodore Roosevelt.

Brady himself continued his photographic work, sometimes renting a small shop to operate independently, sometimes working for old friends who owned galleries in town. He couldn't afford to retire. The Central Park lots, the oil stock, and the mining stock had all been sold. He and Julia still lived at the National Hotel, and there were doctor bills to pay as well. Julia was suffering from a heart condition.

In 1882 there was a succession of bad news for Brady. His Civil War assistant, Tim O'Sullivan, who had taken his camera through the West and down to Panama, died of tuberculosis in January. He was only forty-two. Just two years earlier Brady had recommended O'Sullivan for a job as photographer in the Treasury Department.

Later in the year Alexander Gardner died. Despite Gardner's departure from Brady's gallery, the two had remained friends. Most of the men who had photographed the battlefields with Brady were gone now. There was no one even to reminisce with over the days of glory.

Worse yet was a report from the War Department on the condition of the plates Brady, O'Sullivan, Gardner, and the other photographers had risked their lives to take. From 1875 to 1879 the War

Department's policy was to make copies of the plates for anyone needing photographic records of the war. As a result, a number of them had been broken, scratched, or lost. In 1882 the photographer Edward Bierstadt examined the collection and found that the plates were deteriorating.

He recommended that each plate be recopied with new photographic materials that would be more permanent. By 1880 it was possible to make exact printed reproductions of photographs by a photomechanical process similar to that used for illustrations in books and magazines today. Bierstadt estimated the cost of making printed reproductions would be seventy-five dollars per one thousand plates. But the War Department rejected Bierstadt's recommendation. The only action taken was to refuse any further requests for copies of the plates.

Brady was horrified. Not only had the government taken his work, but now it was allowing it to disintegrate. Every plate broken was a part of the past lost forever. History was disappearing, and once gone, it was gone for good.

It was around this time that Brady began to haunt the halls of Congress, petitioning its members once again for help. He had never been paid enough for his pictures, and now they weren't being taken care of. They weren't even accessible to the public.

A woman who was a public secretary at the Capitol at that time recalled seeing Brady often. "He could not afford much typewriting," the secretary recalled, "but would pour his sorrows in my pitying ear as he waited to talk to one or another of the members of Congress who, he hoped, would help him." She thought of him as a "sad little man," but he was always neatly dressed, fastidious about the care of his clothes, mustache, and beard. He smelled faintly of good cologne.

In happier moods he would tell anyone who would listen about

his days as "Brady of Broadway" and the exciting days of the Civil War. But fewer and fewer people wanted to listen. Occasionally someone would steer a commission for photography in his direction. When they did, the work Brady did was always carefully prepared and technically excellent. He never lost his pride in good work, and no one was ever heard to complain about a Brady photograph.

Except, possibly Brady himself. In 1891 a newspaperman, George A. Townsend, found Brady in a little gallery over the Pennsylvania Railroad Ticket Office near the Treasury Department. The room was still decorated with the historical photographs of presidents, kings, authors, and generals, but it was a far cry from the lavish galleries Brady had once operated on Broadway and Pennsylvania Avenue. Many of the pictures of that time had been sold or packed away.

Years before, Brady's gallery had photographed Townsend with Mark Twain, and Brady told Townsend that Twain too had stopped by just a few days earlier. Brady had enthusiastically shown Twain the pictures he had left. He was trying to interest Twain in bankrolling a project to publish the pictures, but Twain was too busy.

Townsend looked "at the white cross of his mustache and goatee and blue spectacles" and felt "the spirit in him still of the former exquisite and good liver which had brought so many fastidious people to his studio."

Brady reminisced at length about his career to Townsend, clearly enjoying himself. But did he have any regrets? Perhaps a bittersweet one. Brady said, "From the first I regarded myself as under obligation to my country to preserve the faces of its historic men and mothers. Better for me, perhaps, if I had left out the ornamental and become an ideal craftsman."

In 1887 Julia died. Brady, now a lonely old man, moved into his nephew's house, where he entertained Levin Handy's three children with stories of the Civil War. One day, while crossing a street

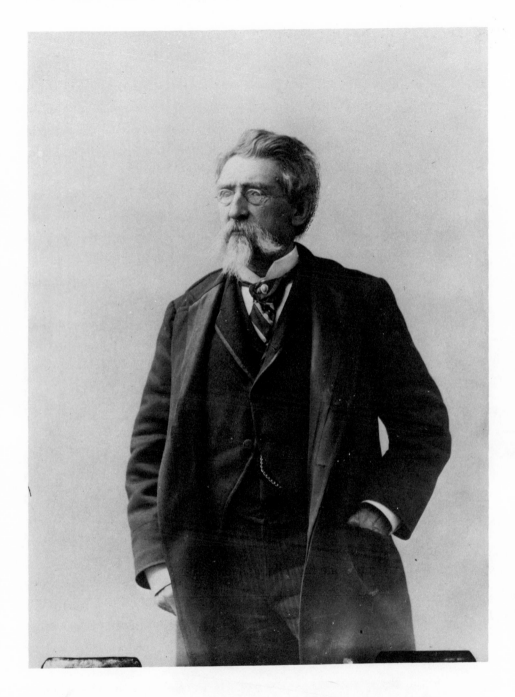

Mathew B. Brady as his nephew photographed him around 1889.

in downtown Washington, Brady was struck by a horse-drawn street-car. He was rushed to the hospital with severe injuries. A man in his seventies doesn't often recover from such an accident. Brady recuperated for a long time. In July, 1895, the last of the Brady galleries was closed and the equipment sold.

But Brady could never really quit. As soon as he was out of the hospital, he began making plans for one last exhibit. People said he was old-fashioned. Very well, he would use the latest in technology, the glass lantern slide. He had a number of Civil War photographs left. They could be copied onto glass slides and projected onto a screen. Entertainers were making money now with lantern slide shows accompanied by a spoken commentary or recitation. What could be more appealing to the public than a selection of Civil War photographs narrated by the man who was actually at the battlefields?

Brady carefully selected a number of plates and left them with Levin Handy to be made into slides. Brady was off to New York, where he began making plans for the opening performance of his slide show at Carnegie Hall on January 30, 1896. During the fall of 1895 he met with Civil War veterans' groups, members of the Artists' Club, and other old friends, enlisting their support. Prominent veterans and New York residents were asked to be sponsors of the Brady showing.

Then Brady fell ill. From his sickbed he continued making plans, sending a man to Brooklyn to search for a lantern slide projector, writing his nephew to urge him to complete the preparation of the slides. A general from Grant's staff agreed to make the introductory address at the slide show.

But Brady's illness grew worse. On December 16 he was taken to the Presbyterian Hospital. An old friend, William Riley, who was helping Brady organize the show, came to visit him every day. Brady

talked of recovering in time to open the show as scheduled, but Riley's eyes filled with tears. He could see Brady was not going to make it.

On January 15, 1896, Brady died. His friend Riley went to the little room Brady had rented for the last few months of his life, to collect his possessions for Brady's nephew. All that Brady had were two old suits, some shirts, a broken satchel, and the beautiful cane and ring given him so many years before by the Prince of Wales, when Brady had been the prince of New York photographers.

A few newspapers remembered Brady in obituaries. His nephew raised the money to purchase a grave stone in Arlington National Cemetery, where Brady was laid to rest among the Civil War veterans.

But Brady's real memorial was all over America in homes in the North and South. Families treasured the solemn faces of the dead boys kept forever young on the cartes de visite that Brady's studio had made. Boys who had never grown up, who had stopped at Brady's for a picture to send home before they marched off to battles where Brady and his men would later record the unseeing eyes of the same dead boys.

Brady's dream was that the priceless collection he had gathered would become the nation's treasured memory as well. But the nation avoided the memory of the painful days that Brady had preserved. History has a sloppy memory. Brady's vision was too painfully sharp. History rewarded him with a tombstone on which the date of birth is in doubt and the year of death is given as 1895. Brady died in 1896.

Brady's only real reward is that he lies at Arlington among the honored dead. Brady told the journalist Townsend, "I loved the men of achievement!" His memorial is the faces of the men of achievement, recorded for all generations to see.

INDEX

Note: Photographed subjects are listed by italicized page numbers in the following general index.

ILLUSTRATION CREDITS

THE AUTHORS

Dorothy Law Hoobler grew up in Yonkers, New York, and graduated from Wells College. She received her master's degree in history from New York University and has worked as a free-lance editor and writer for several years. She and her husband, Thomas Hoobler, have a daughter born in 1976. They live in New York City.

Thomas Hoobler is the co-author with his wife Dorothy of ten books. He graduated from the University of Notre Dame with a degree in English and studied at the Writer's Workshop of the University of Iowa under Kurt Vonnegut. After teaching photography and English in a private school in Cincinnati, Ohio, for several years, he came to New York where he married Dorothy Law. Besides being a free-lance writer, Mr. Hoobler is an editor of a trade magazine.